BECKENHAM

THROUGH TIME

David R. Johnson

AMBERLEY PUBLISHING

Acknowledgements

This book would not have been possible without the help of many people who have allowed me the use of their pictures, and have been very helpful with information. Regretfully, I had too many items in the end and many will be disappointed that I was unable to include their subjects. The Nancy Tonkin Collection of photographs provides most of the material, and my thanks go to Bill Tonkin for the use of this invaluable resource. Cliff Watkins was also a major supplier of images. My special thanks to him. Two individuals who helped on specific items are Mrs Clarke, on C/Sgt Bourne, and Peter Holliday concerning the Territorial Army local history. The staffs of Bromley and Beckenham libraries were very patient in dealing with my enquiries so efficiently, and deserve much praise. My thanks to Colin Gale, archivist at Bethlehem Royal Hospital, whose help was much appreciated. Likewise, I'm obliged to the estate of Rob Copeland. A thank you to Winston Ramsey, editor of *After the Battle*, for his photograph of Winston Churchill. Finally, I have to thank my neighbours, above all one in particular – who wishes not to be named – who gave me constant and invaluable computer help.

This book is dedicated to the memory of my recently deceased brother, Leonard Frank Johnson, who showed a great interest in local history and encouraged me in this fascinating subject.

First published 2014

Amberley Publishing
The Hill, Stroud
Gloucestershire, GL5 4EP

www.amberley-books.com

Copyright © David R. Johnson, 2014

The right of David R. Johnson to be identified as the Author of this work has been asserted in accordance with the Copyrights, Designs and Patents Act 1988.

ISBN 978 1 4456 1976 7 (print)
ISBN 978 1 4456 1985 9 (ebook)

British Library Cataloguing in Publication Data.
A catalogue record for this book is available from the British Library.

Typesetting by Amberley Publishing.
Printed in the UK.

Foreword

As the son of a military officer, who spent his early childhood abroad with his parents, before attending boarding school and then joining the Army, I never had a home area anywhere in England. That all changed when I was elected as the MP for Beckenham in 2010 and I moved here. Although I was not born locally, Beckenham is my home now and I hope I will live here for the rest of my days.

I have always greatly enjoyed history and, when I first came to Beckenham, I spent quite a while examining the old photographs in the waiting room at Beckenham Junction station. Beckenham and the area around it looked beautiful, ordered, and fascinating in those old prints and so David Johnson's new book, with its photographs, descriptions and modern-day views, intrigued me.

I had no idea that the first train from Beckenham Junction station pulled out on New Year's Day in 1857. I did know that the first airmail in England was delivered by a balloon that left Croydon Road Recreational Ground in 1902, but I had never seen a photograph of a balloon in the park until David's book. Then, as an ex-soldier, I was thrilled to learn that C/Sgt Bourne DCM, a hero of Rorke's Drift (and the film *Zulu*), was a long-time local resident, and is buried in Beckenham Cemetery. I had no idea that more civilians were killed in and around Beckenham in the Second World War (164 men, 144 women and 22 children) than local sons and daughters who went off to war in uniform. True, I had heard that local boy David Bowie performed in the Three Tuns in 1972, but I didn't see the plaque saying that until David's book directed me to Zizzi's in the High Street.

David Johnson is a local through and through. Born in Beckenham, he has lived here all his life – except for understandable gaps away, such as during national service in the Royal Artillery, or as a civil servant and with British Telecom. His interest in local history is clearly intense, not just because of his long-time membership of Bromley Local History Society, but also by virtue of the fact that he still conducts history walks in Beckenham, Penge and Crystal Palace. This is his fourth book on local history, but it is his first that exclusively concentrates on Beckenham and its surrounding areas.

Personally, I will be reading, enjoying and walking around its subject locations, guided by David's book, for the rest of my life. I completely commend this immensely enthralling read to anyone who loves searching out and discovering just how things were for those who came before us.

Colonel Bob Stewart DSO
MP for Beckenham

Introduction

Traces of a Roman road linking the London area to Lewes can be found through the length of the Beckenham district of 1934–65. In these years, the area of Beckenham encompassed West Wickham, which is included in this book along with the Crystal Palace area. Transport improvements led to development of the area and are therefore included. The Croydon Canal (1809–36), crossed the north of Beckenham Parish, and was purchased by the London & Croydon Railway Co. in 1836. The canal was replaced by the railway, which opened on 1 June 1839. The railway was later continued to Brighton to become the London Bridge & South Coast Railway, (LB&SCR). The rail link was probably the major factor in bringing the Crystal Palace here. A branch line from the LB&SCR was constructed to the new Palace, and opened on 27 March 1854. A very early railway flying junction (or flyover) was built, mainly in Beckenham, to allow the branch line to cross the main line. The new Crystal Palace was opened by Queen Victoria on 10 June 1854. The new building was a fashionable attraction, and in turn engendered more development. Long before railway transport, this locality attracted many wealthy families because it was possible by horse, or later by horse and carriage, to get to London and back within a day. In any case, the area was attractive with fertile soil and plenty of woods where game could be kept. Important people settled here and mansions and estates such as Langley have left a legacy with names of roads and, more importantly, attractive parklands. More than one of the London Lord Mayors lived here over the centuries. The Hoare family were residents here and to some extent we owe them thanks for the beautiful Kelsey Park.

Beckenham, with its many open spaces, retains much of its historic and attractive rural atmosphere. However, the old Parish of Beckenham was urban by the late nineteenth century after the arrival of the railway in 1857. Some older, long-standing residents still refer to the high street as 'The Village'. The author remembers chickens running free only a pavement's distance from the main road near The Three Tuns, as well as the disused wheelwright and smithy buildings in Burnhill Road. In 1935, Beckenham became a borough, after West Wickham had been added, so that it was of sufficient size to claim this status. This amalgamation included common and farm land, which today continue to be an easily accessible asset. Another reorganisation in 1965 put Beckenham into the largest Greater London borough, a change of administrative county from Kent. The name Bromley was chosen as the name for the new borough, formed of five distinct administrative districts: namely Beckenham, Bromley, Chislehurst, Orpington and Penge. People in each of these districts maintain their own identity.

The character of Beckenham is constantly on the move. The site of the Welcome Foundation, (later GlaxoSmithKline) at Langley Court is changing as this book is prepared. In part of the grounds, there are private gated estates and Langley Court is virtually inaccessible to the public. The loss of this enterprise along with others, like Muirhead, appears to be a great economic harm. Perhaps Beckenham is in line with the rest of the country and prosperity seems to be growing in spite of these changes.

It is impossible to include in this book all the notable people, churches, schools, pubs, parks and important buildings. The main roads, like Beckenham High Street, are well represented, see maps on page 96 for further reference. They are known to most people, and it is hoped that readers will get a better knowledge and understanding of these areas. The many restaurants in Beckenham, attracting visitors from a wide area, show that the locality still has its charms for all to enjoy.

Administration and Parks

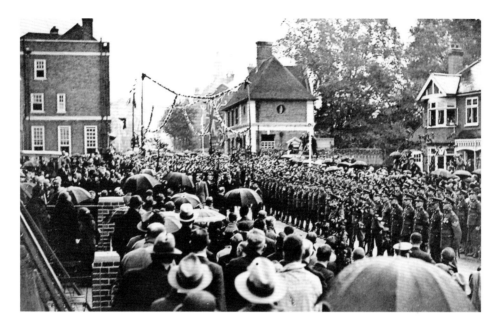

Prince George at Beckenham Town Hall
The future King George VI opened the new Beckenham Urban District Town Hall on 20 October 1932 – a wet Friday. He was Prince George at the time, a name given to his great grandson in 2013. Sadly, this fine building has gone and yet the scene adjacent, other than changes of trees and inevitable parked vehicles, has changed very little.

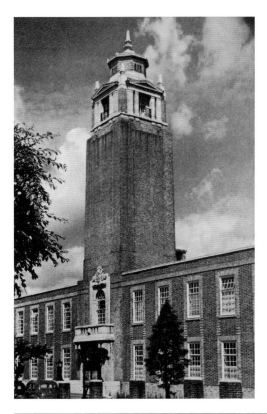

Beckenham Town Hall, *c.* 1933
The distinctive town hall was the pride of Beckenham from 1932 to 1965. Beckenham was transferred to the Greater London Borough of Bromley in 1965, and eventually the site was sold and now serves as a car park. Marks & Spencer now occupies the side of the High Street that previously contained the town hall and Electrical Showrooms. Welfare services, such as the school's dentist, Mr Walters, were included in the building where, in the 1930s, mothers would tend their children after treatment. It was always soft-boiled fish for the author's next meal.

Beckenham Coat of Arms

The 1999 photograph is the armorial representation at the Wickham Road entrance to Kelsey Park. The later full representation is at Beckenham Green. The Beckenham Coat of Arms was granted in 1931 when the area was urban; however, it depicted the area's past within a rural green setting. In this image, the chestnut trees are in bloom, demonstrating the beauty of Beckenham, where shrubs and trees grow well in private gardens and public parks. The two wavy lines represent the two main streams: the Chaffinch and the Beck. The Beck was unfortunately and mistakenly given this name by the earliest Ordnance Survey officers – formed from the modern spelling of Beckenham. The correct name on old maps is the colourful 'Hawksbrook'. The white horse is a symbol of Kent, and the Tudor supporters fit in also with Wickham Court history. The motto means 'Not for ourselves alone'.

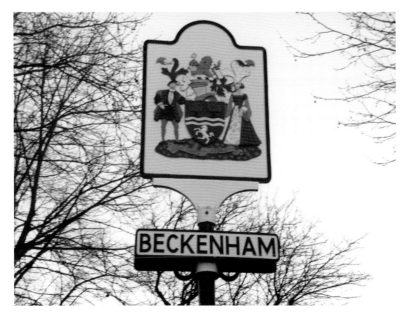

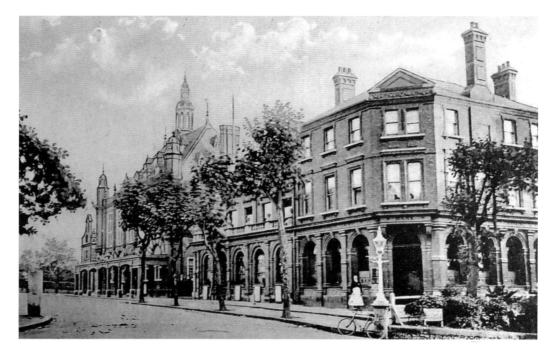

Public Hall, Local Board Offices, *c.* 1900
The absence of traffic adds to the attractiveness of the old scene. The then fire station is in the distance. The old town hall, now public hall, had its ornamental rooftop cupola. The old council offices are to the right. The original manor house stood on the site of these buildings. The London & County Bank, now replaced by the National Westminster Bank, stood on the corner. The tall milestone on the left, in the old picture, was damaged in the 1970s by an unknown vehicle and was moved to a less vulnerable corner on the right.

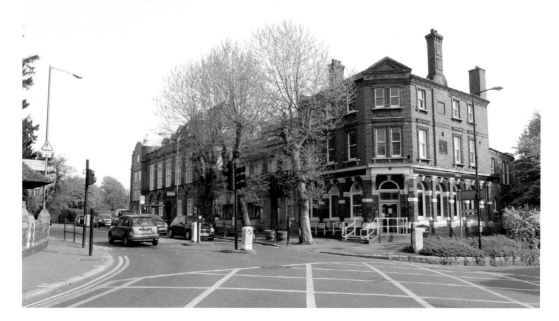

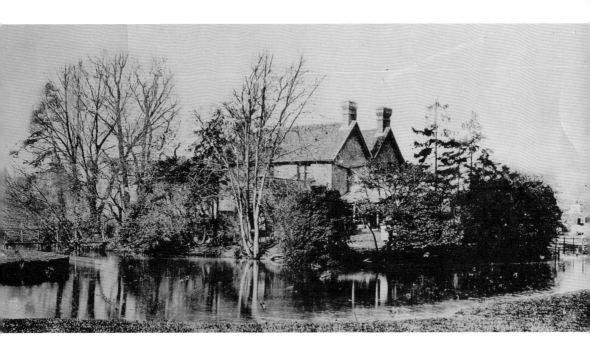

Foxgrove

Foxgrove was a manor house with lands stretching from Southend Road to the River Ravensbourne. In the early nineteenth century, it was called Foxgrove Farm, rather than manor. It was demolished around 1878, allowing the present large houses (illustrated) to be built. The original manor was about 600 years old and it was moated, which shows its antiquity. The water from the moat was used by the volunteer fire brigade in their practices. The farm buildings were centred near where the photographer is standing, and covered several of the neighbouring gardens and houses. There is no obvious trace of the old building today.

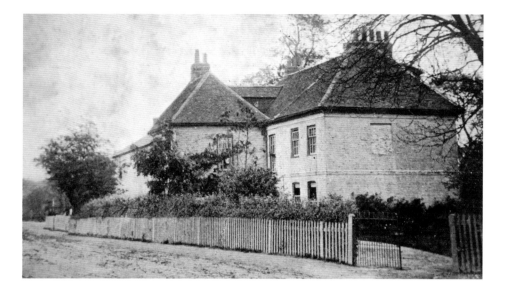

Kent House, c. 1890

The name of the house is said to derive from it being 'the first house' when approaching Kent from London. In fact, it was approached from Surrey, so perhaps this should be substituted for London. When the house was named, the Kent border continued northwards, reaching the Thames at Deptford. There were several main roads and Kent houses nearer to London than a Beckenham house that stood on the border with Penge, then in Surrey. The land here is very fertile and would be a rich reward for a high courtier who probably had estates in a number of counties. The estate is recorded in the twelfth century, and later Sir Richard de la Rochelle purchased it (c. 1246). There were many famous names associated with the property, including Lethieulliers, Pepys, Angerstein and Thackery. Angerstein's collection of paintings formed the nucleus of the National Gallery collection. He was also notable for reorganising Lloyds of London in 1774. The house (or manor) became a working farm in the nineteenth century when it was known as Kent House Farm. In the twentieth century, it was first a nursing home and then a private hotel. The author explored the redundant farm buildings in the 1940s and was sorry to witness its demolition in 1957. The site now provides many desirable residences.

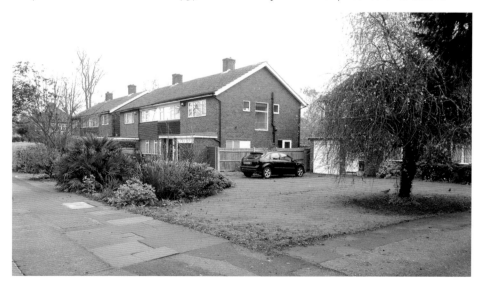

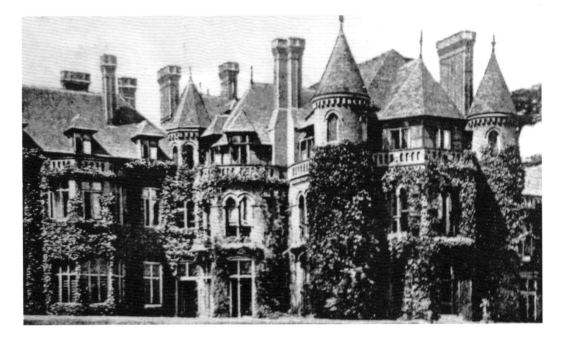

Kelsey Mansion, *c.* 1900

Peter Richard Hoare, of the banking family, bought Kelsey in 1835 and died there on 10 September 1849. The Hoare family converted the house to a Scottish baronial-style mansion. Between 1895 and 1901, the mansion was used as a convent, and after that it was Kepplestone School for the Daughters of Gentlemen. Kelsey was bought by the local council in 1911, and it was used by the military in the First World War. It was demolished in 1921, and replaced by houses in the prestigious Manor Way. Only a ridge in one of the back gardens, shown here, remains to show where the mansion once stood.

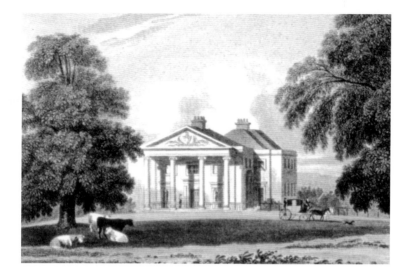

Beckenham Place, c. 1820

John Cator (1738–1806) had this country seat built in the mid-eighteenth century. The columns were added in 1784, which formerly belonged to Wricklemarsh Place in Blackheath. The road from Beckenham to the main London road was diverted from near the building to where Southend Road is today. Dr Johnson was entertained here, and recorded that it was one of the finest residences that he had ever visited. From the mid-nineteenth century, the building was rented out. In 1902, Craven College, a boys' private school, hired the building until 1905. It had other tenants until 1928, when the London County Council purchased it along with the whole park area. It is now in the hands of the borough of Lewisham. The surrounds are now a full-sized public golf course where anyone may exercise. Refreshments, including meals, are available in the lower ground-floor restaurant. At weekends, the front ground-floor premises may be viewed, and volunteers assist the public to view their many ecological and historical displays.

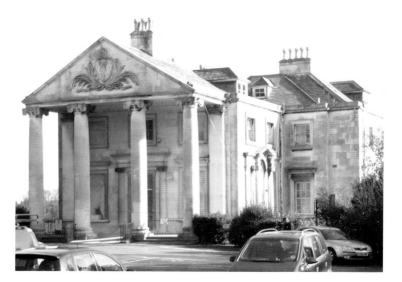

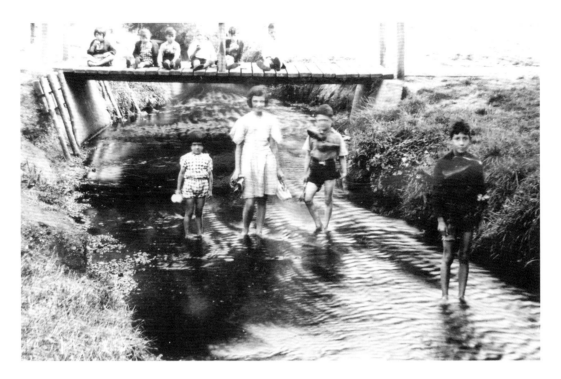

Cator Park, *c.* 1930

The River Chaffinch, in its natural state, provided endless joy to children paddling or possibly catching fish. The river, in a culvert right through the park, now precludes these pleasurable activities and has destroyed the beauty of the stream. One recent improvement has been to allow cycling on some paths, which is much safer than on the very busy roads.

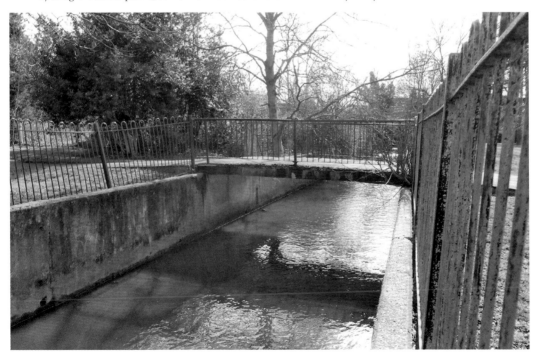

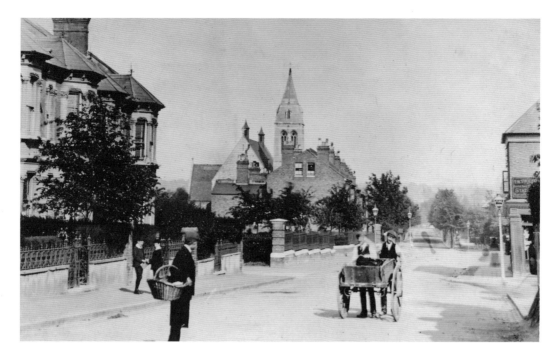

Lennard Road near Alexandra Park, c. 1900

Alexandra Recreation Ground opened in the late nineteenth century. Some records suggest that a Penge Cricket Ground had already existed at the Sydenham end for many decades earlier. There are smart railings around the 1900 park, and the main entrance faces Lennard Road. This tranquil scene shows very little traffic, which contrasts with 2014 where dangerous traffic and parked cars obscure the view. A continuous hedge now faces Lennard Road, since the smart gates and railings were collected for scrap metal during the Second World War. The spire of Holy Trinity church is obscured by trees in the modern view, but much of the housing remains constant.

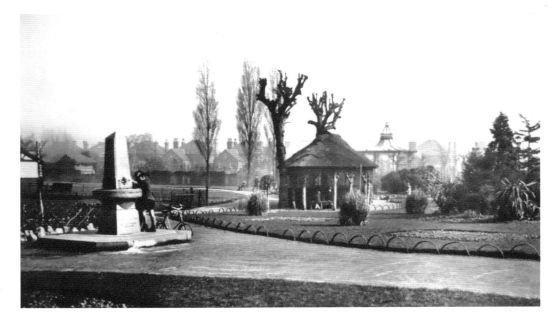

Alexandra Recreation Grounds, c. 1930.

The children drink at the nineteenth-century fountain, which certainly operated until the end of the Second World War; however, it no longer functions. The lovely, old, rustic thatched shelter was destroyed by arson around 1970, and the bandstand has been removed. Earlier bands, such as the local Salvation Army, played here regularly in the warmer weather. There was a charge for the chairs placed in the band enclosure. Many others would enjoy the music a little further away, without cost, sitting on the grass. One facility that has survived is the bowling green, which can be glimpsed in the 2014 picture. An identical bandstand and railings still exist at Croydon Road Ground.

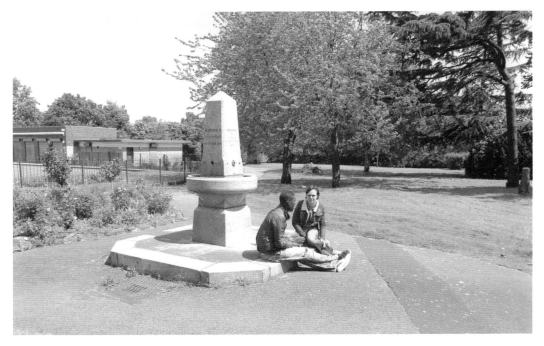

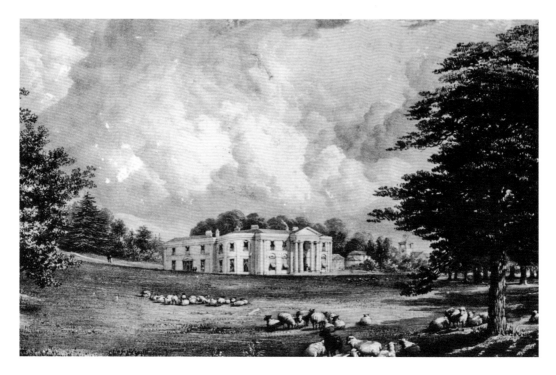

Eden Manor or Eden Farm, *c.* 1790

William Eden was resident here at the end of the eighteenth century, and it was where he entertained William Pitt the Younger, Wilberforce and other notables. The elegant Eden Park, or estate, stretched down to Croydon Road. The very large house had a magnificent view that can be appreciated standing on the site in Crease Park today (*shown below*).

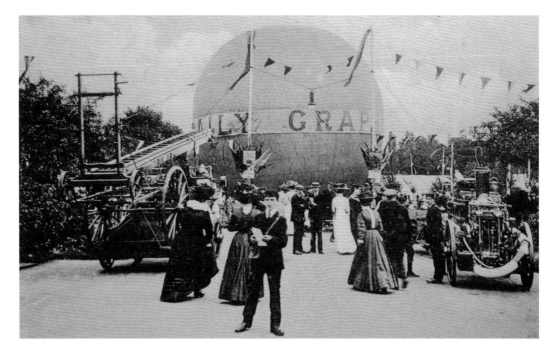

Croydon Road Recreation Ground

One of the many notable activities at this park in central Beckenham was the launching of balloons. This is a picture of the Beckenham Flower Show in 1905. The balloon is inscribed with the newspaper, *The Daily Graphic*. Mail was taken on the balloon. The first airmail was organised from the same spot in 1902, and the mail was dropped over Kent. Elegantly dressed ladies are very much in evidence between the two fire brigade vehicles. Spring flowers are budding in the same spot, on a cold day in 2014.

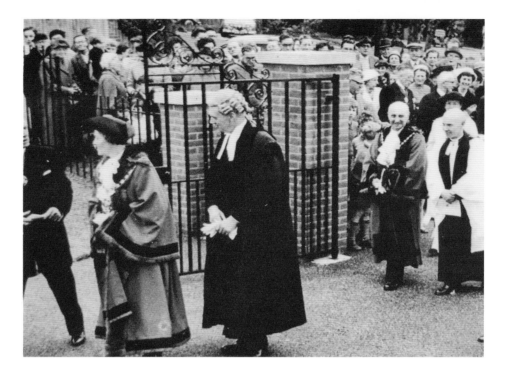

South Hill Woods Opening, 1959

South Hill Woods is a park within the old parish of Beckenham. It is a remnant of the ancient woods called Toots Wood. Sir Thomas Dewey (1840–1926) purchased the estate for £1,581 5s in 1887. During the First World War, he converted his music pavilion into a hospital for wounded Belgian soldiers, and was subsequently honoured for this by the Belgian King. Ownership changed hands and, in 1952, Beckenham Council compulsory purchased the estate, which was opened on 2 May 1959 as a park. The Blue Plaque on his former residence now commemorates Thomas Dewey's work.

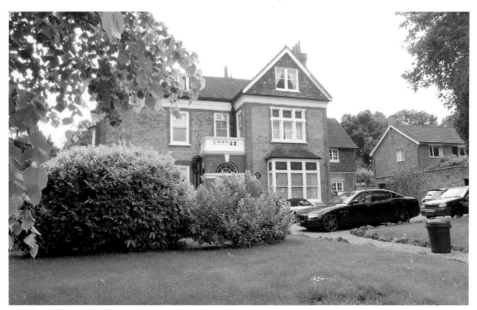

High Street

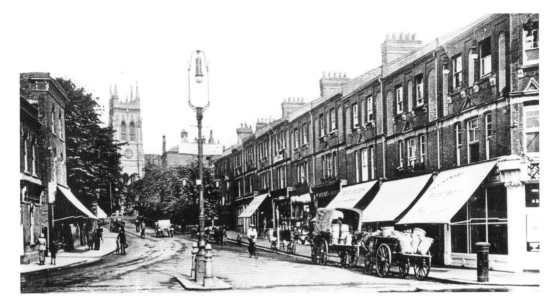

Church Hill, *c.* 1910

The name is now High Street for this hill leading to the church. The church tower, completed in 1903, dominates both scenes. It is part of the enlarged church, built by the architect W. Gibbs Bartlett, to accommodate the increasing population. Furley & Baker, the sports shop on the right of the modern picture, has been in business since 1927. The original Furley was the son of Sir John Furley. Baker was the son of a stockbroker. Since then, the business has exchanged hands four times. The police station on the upper right of the hill was opened by Squire Lea Wilson in 1885, and was converted to leisure use recently. The ground floor has two successful businesses: a restaurant and a beauty parlour.

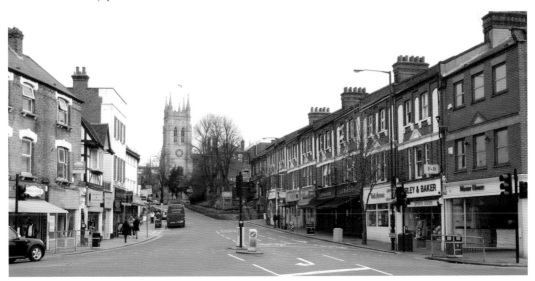

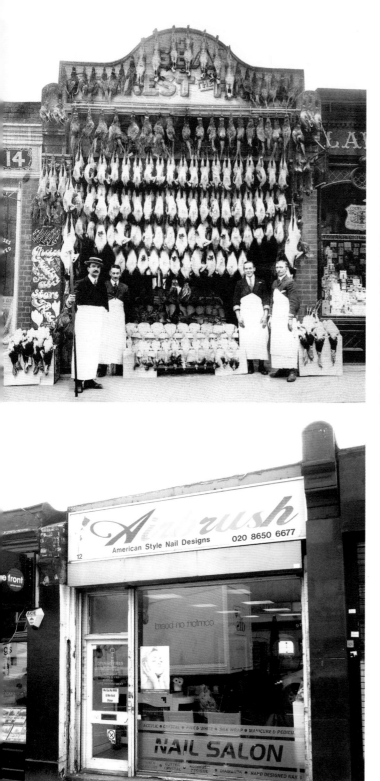

Chalks, c. 1925
In 1925, V. B. Chalk is listed as fishmonger and poulterer at No. 12, the High Street. The proud display here is for Christmas, as shown on the board to the left and the large turkeys on display. The numbers have not changed in this part of the High Street, and now the premises houses a nail bar.

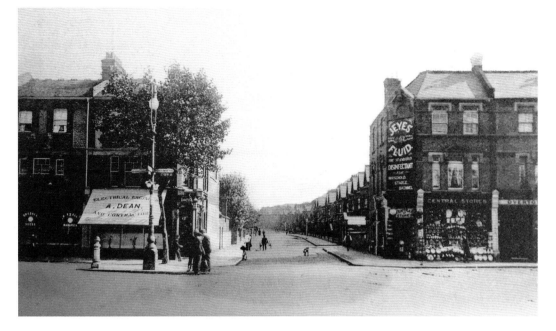

Junction of Church Hill and Manor Road, c. 1900

It is perhaps surprising to find a shop (*left corner*), dealing with electricity in 1900; however, this is indicative of local prosperity. The district was a leader in supplying highly desired electricity, with early demand at the Crystal Palace. A Crystal Palace & District Electric Light & Supply Company operated in the Lawrie Park neighbourhood in the early 1890s. This prompted the Beckenham Council to build a municipal power station in 1900, in what is now the Church Fields Road area. Later, the council owned its own electricity showrooms. In the 2014 picture, three of the four shops shown are letting and house agents, and there are another four within 40 metres.

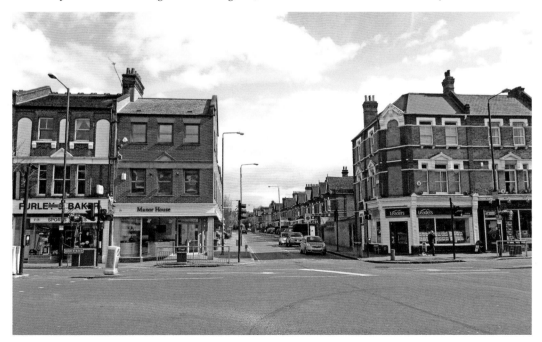

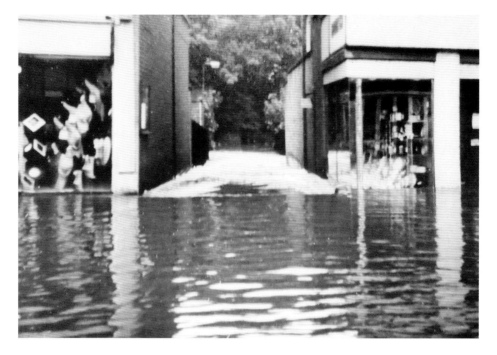

Flooding, 1968

The river that flows through Kelsey Park periodically overflowed its banks in the lower High Street. The normal course of the stream at this time, was underground in the gap between the shops. The more recent canalisation of the water appears to have solved the problem in the very wet winter of 2013/14. The manager of the card shop reported no problems in that winter.

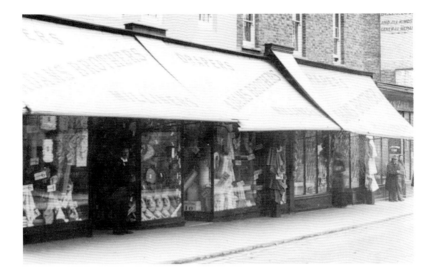

High Street Stores, 1903

Adam's Brothers stood at Nos 66, 68, & 70 High Street. The numbering here has changed. The milliners and haberdasher had smart window dressing (*c.* 1903). The older buildings have been replaced by the first four shops in the coloured photograph. This is to show exactly where Adam's store stood. Today, a Turkish restaurant operates where the wing-collared gentleman is shown in the old picture.

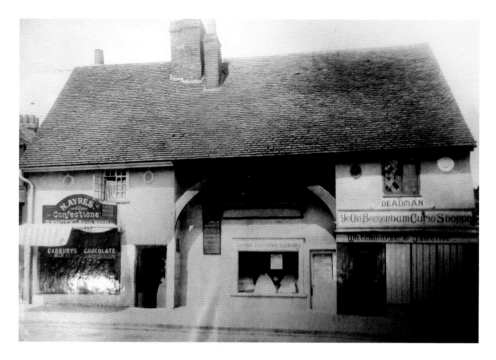

The Old Wood House, *c.* 1900

The house has been adapted to make three shop fronts, which from left to right are: N. Ayers (confectioners), a laundry and jeweller's. When the house was demolished, *c.* 1935, it was found to have been a yeoman's house and at least 500 years old. There were originally no chimneys, just a hole in the roof to let out the smoke of the central fire. The yeoman and his family would have had some privacy; the rest of the inhabitants shared the central area. We might call this demolition vandalism today. WHSmith took over the building, and is at least still in business.

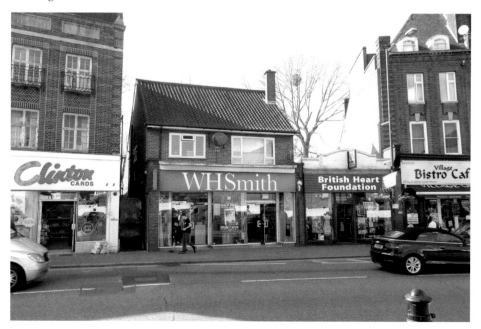

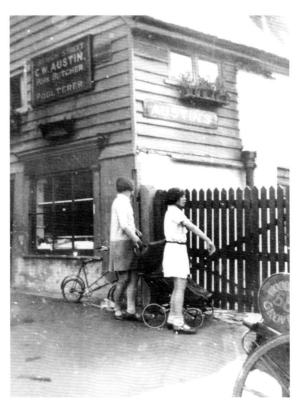

Austin's Butcher's Shop, c. 1960
The author, and many others, can remmber chickens wandering on the land behind the fence This seems incredible in the present age, where the high street is lined with buildings. The seventeenth-century building, was previously the estate gardener's cottage before the Austin family converted it into a dairy and pork shop. It was demolished in the 1960s, and a café now stands on the site of Austin's shop, right next to The Three Tuns. Today, to the left, can be seen the old fire station, a relic of the old scene.

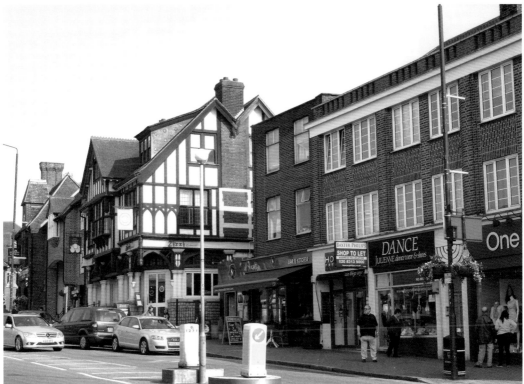

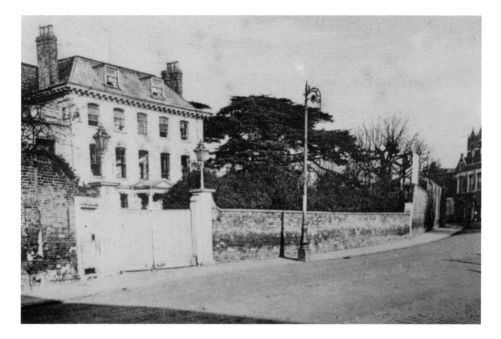

Village Place and Ardec

The house was the home of Squire Lea Wilson and earlier of Samuel Wilson, Lord Mayor of London in 1838. In the First World War, it was used by the military, and in 1920 it was demolished. 'The Drive' was the road to the old mansion. The house was formerly called The Cedars, and Cedar Parade is the name of the row of shops which replaced the frontage. A gentlemen's outfitters, was established by Cyril Oakes in 1925 in Cedar Parade, his grandson, Roger Oakes, explained. The name ARDEC was created as an anagram by Cyril Oakes. He had proposed RADEC, but another company had this name, so he switched the 'R' and the 'A' on the spot at Companies House. The business continues in the same family with Mr Roger Oakes' daughter, as a fourth generation, directing this much respected firm. Unfortunately, the business closed in July 2014.

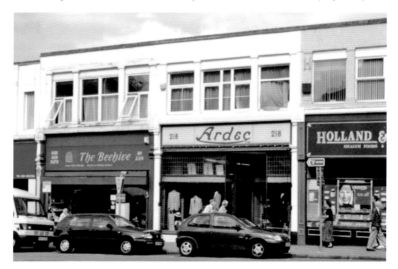

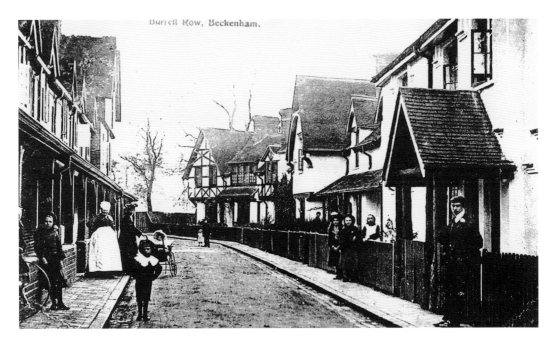

Burrell Row, Beckenham.

Burrell Row, *c.* 1890

The short road was named after the major land owner Peter Burrell, later Lord Gwydir, who died in 1820. At this time, the area was mainly great country estates. However as more – and smaller – country seats were built after 1820, more houses were needed for those that serviced the growing households of the local gentry. In 2014, the road has seventy commercial offices and is a service road for shops. Shaftesbury Road now connects Burrell Row to Croydon Road; only the trees remain a constant.

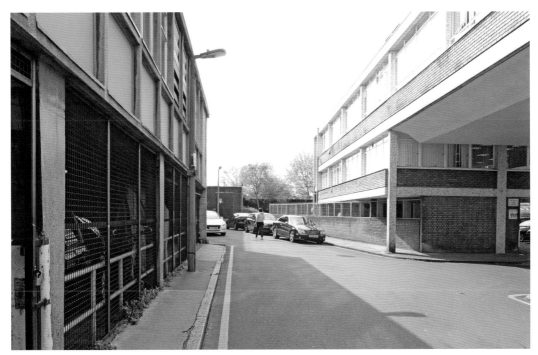

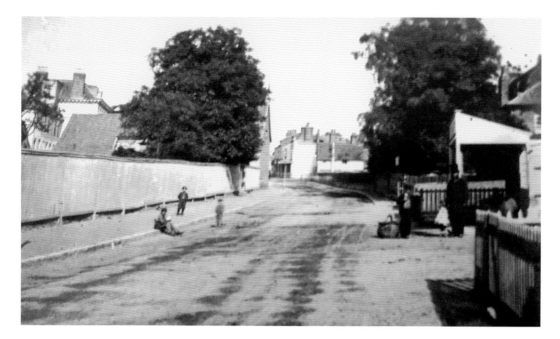

Beckenham High Street from Near Burrell Row, c. 1890

Village Place, where the village squire lived, can be seen clearly to the left in the nineteenth-century picture. In 1890, the Village Place grounds abutted the road as seen in the picture. In the opposite direction, the grounds stretched to the top of Church Hill where Squire Cornelius Lea Wilson had a gazebo. Here, a servant was placed to signal that the coach was returning from London. Descendants of one such lookout servant still live in Beckenham. The building in the distance is The Three Tuns, which is now the restaurant Zizzi. In 2014, the road here is the broad and very busy Beckenham High Street, contrasting with the earlier rural atmosphere.

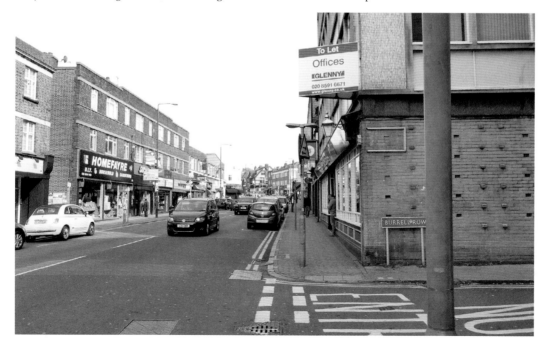

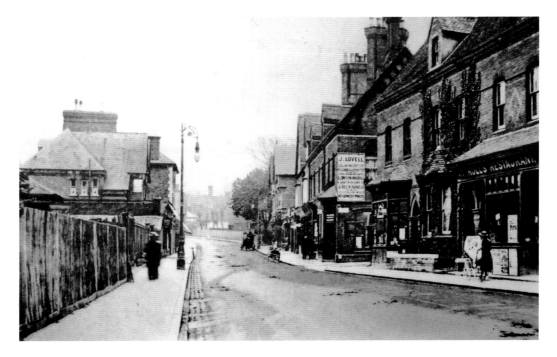

High Street from Near Croydon Road, *c.* 1900

The road was narrower in 1900, and so road widening has removed the premises seen on the left. The right-hand side kept its original line. On the corner of Burrell Row is a business called Lovell, which advertises itself as a plumber, painter and lawnmower agents. Further up, Village Way had not been developed; however, some of the buildings – with diaper brickwork on the right – remain today to please the eye.

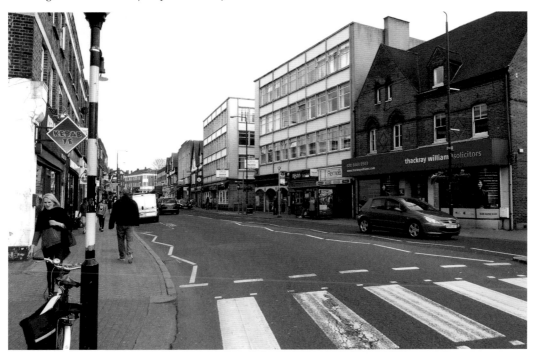

Public Services and Public Houses

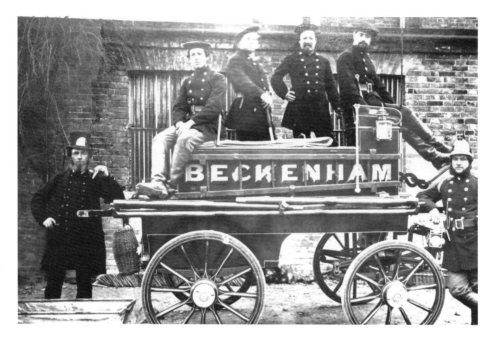

Fire Brigade, c. 1885
In 1882, the fire brigade moved from the High Street (nextdoor but one to The Three Tuns), to Beckenham Manor House stables, in Bromley Road. The old stables were adapted at that time and continued to be used until 1986. The transport was horse powered, as indicated outside the Bromley Road Fire Station. This continued until 1908, when a motor cycle, the 'Tri-Car', was purchased. When the current combined Fire and Ambulance Station was opened in 1986, Philip Goodhart (Beckenham's then MP) doubted the wisdom of placing it on a rather narrow stretch of road. The modern crew look as though they will overcome most difficulties.

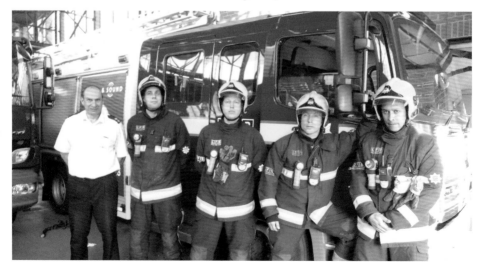

Maternity Hospital Stone Park, c. 1986

The Stone Park Maternity Hospital opened in 1939, and served the area until 1986. A very large proportion of local people must have had some connection to this hospital. On the site now stands Coopers Mews, which provides a very high standard of sheltered accommodation. It is owned by Morden College. The present construction was opened by the Mayor of Bromley, Cllr Mrs Dorothy Laird, on 19 May 1992.

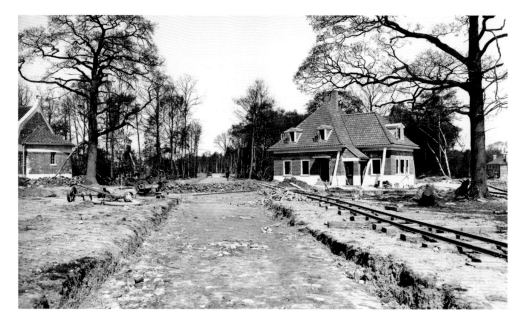

Bethlem Royal Hospital

Between 1926 and 1930, a temporary standard gauge railway conveyed building materials from south of Eden Park station to the site of the new hospital. The goods were distributed around the site by a 2 foot gauge railway and engines, purchased from the War Department, having previously served the trenches on the Western Front. On 9 July 1930, Queen Mary opened the new hospital, with little security compared to today's standards, as she left her car. The earlier hospital buildings were in central London, the last of which now serves as The Imperial War Museum. Treatment has improved vastly over the 700 years of Bethlem's existence and it is now recognised as the first hospital in Europe specialising in mental illness.

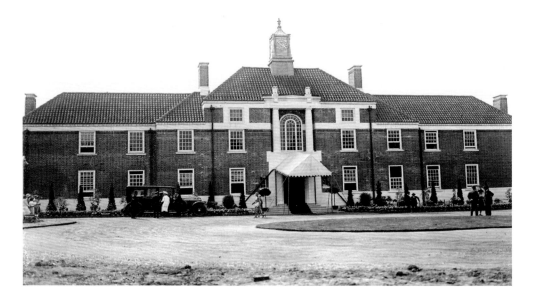

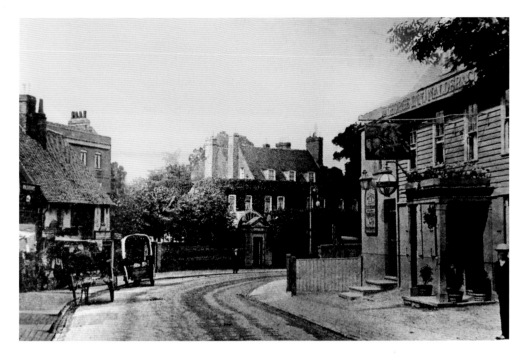

The George, c. 1905

The George Inn dates from at least the seventeenth century, and is almost certainly the oldest public house in Beckenham. The Old Wood House is on the left, with two carts standing nearby – this was a yeoman's hall. Further down can be seen the Manor House; this is only a name for the large mansion with its covered entrance. However, The George Inn remains on a busy and much changed road, still providing the same service in the twenty-first century.

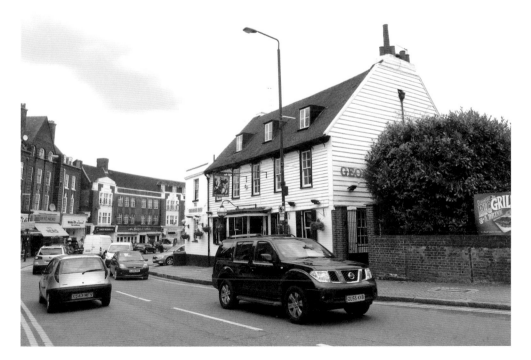

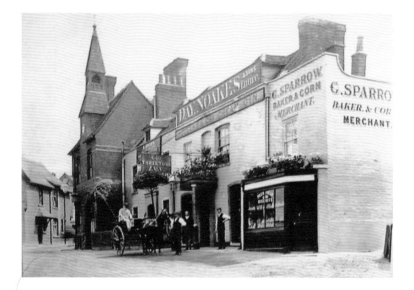

The Three Tuns, *c*. 1900

The public house seen here was replaced by the present larger building, *c.* 1905. However, the old buildings at the entrance to Burnhill Road help to identify the high street area. At the end of the nineteenth century, the fire brigade engine was kept where there is a hairdressers today. Moving to the right, the police station was housed in the cottage adjoining the Three Tuns Inn. The police station moved to Church Hill in 1885. The fire station also moved to Bromley Road in the same year; both to the grounds of the old 'Manor House'. The original police station stood where there is an entrance to allow cars access to a courtyard behind the public house. Although this is now Zizzi's restaurant, a plaque records that David Bowie performed here at the Three Tuns in 1975.

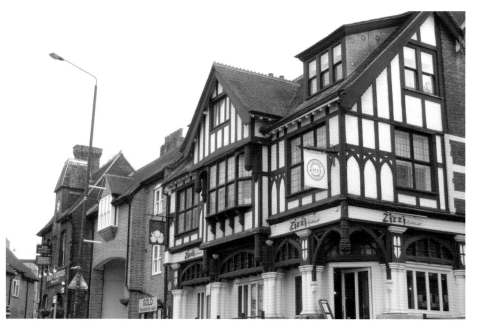

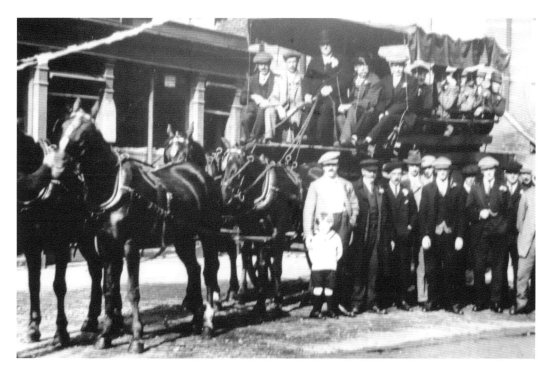

Coach and Horses, *c.* 1910

The horse-drawn outing from this old inn was possibly for the Derby, or another sporting event. In early 2014, the photographer arrived on a day that England was playing Wales at rugby, and the inside was packed with fans with a choice of several screens to watch the live broadcast. In 1910, the Coach and Horses was appropriately adjacent to a smithy and a wheelwright's shop.

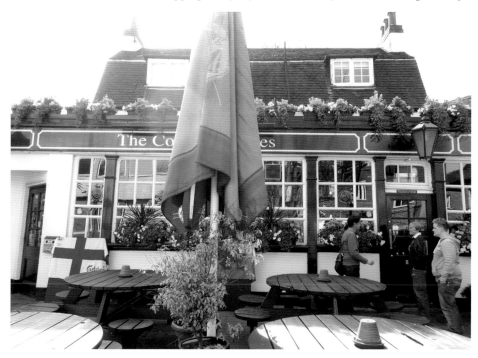

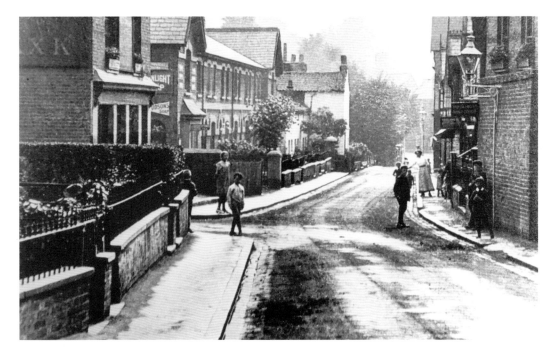

Chancery Lane, c. 1910

The children may play safely in the lane, though in 1910 there were no bollards barring the way as there is today. This district was one of the first to provide accommodation for the people who worked in the large houses of the nineteenth century. One young couple moving into these now expensive houses were amused by grandmother's remark, 'but that's where the servants live.' The Woodman pub on the left is popular today, providing tasty meals and an 'old world' atmosphere.

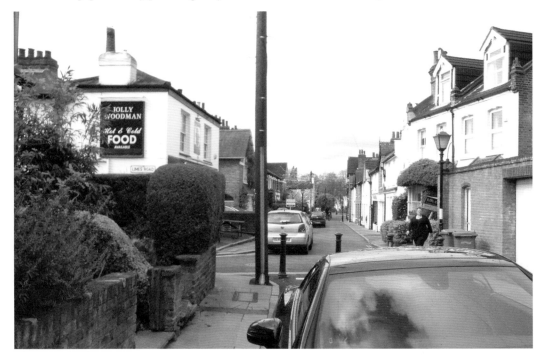

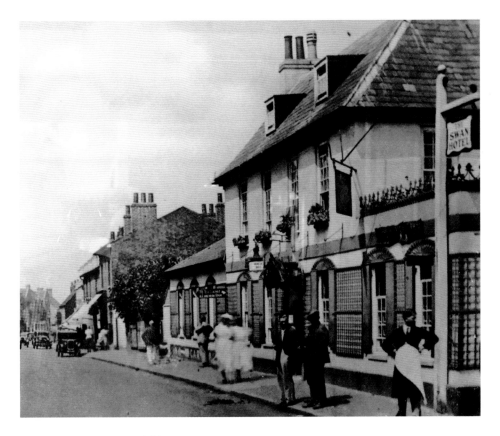

The Swan Inn, West Wickham, c. 1925

The building dates from the 1840s, replacing an inn that occupied the site, *c.* 1745, when it was called Smethes. It has been called The Swan since at least 1838, and is at the centre of West Wickham. In 1935, the Stocks Tree, which stood at this road junction, was removed. Earlier the village stocks stood here to punish minor crimes in this very public position. Did anyone give a drink to a victim in hot weather?

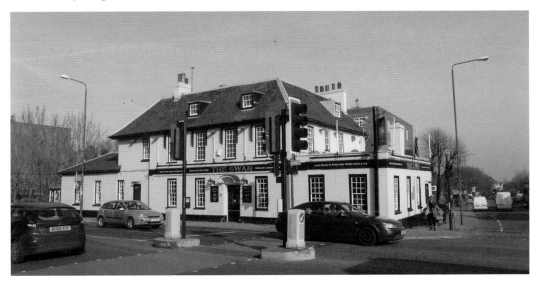

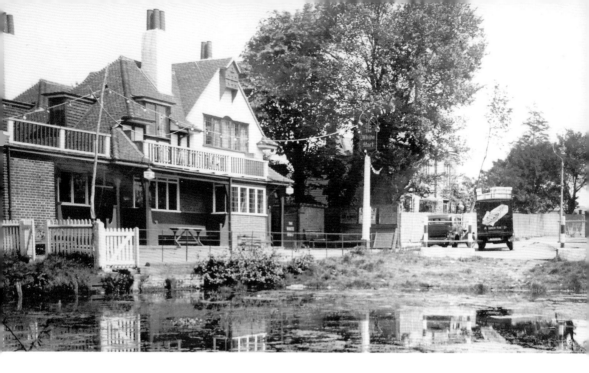

The White Hart, Surrey Border, *c.* 1900
The cart is marked 'Croydon', a place with which there was much commerce. The White Hart replaced The King's Arms, which stood on the opposite side of the stream. The present building dates from 1909, and has recently changed its function to a restaurant with the name La Riojan. The inevitable car park has replaced the pond.

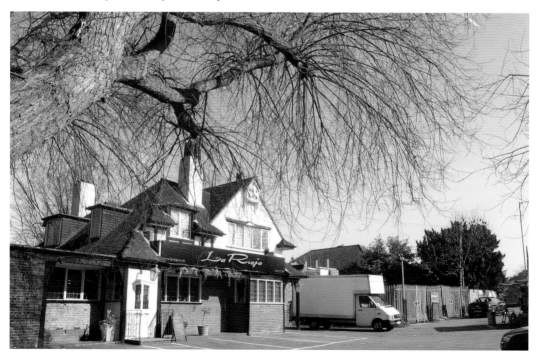

Transport

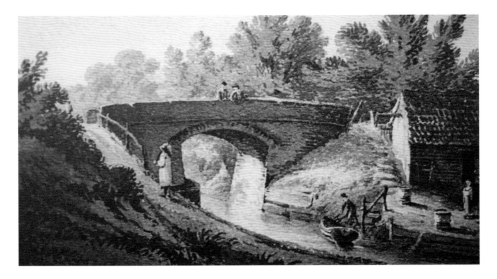

Canal at Beckenham Wharf, c. 1820

James Bourne, the artist, called this picture *Penge Bridge*, which is shown together with Beckenham Wharf. The canal was called the Croydon Canal and it cut through the Crystal Palace strip of Beckenham. It opened in 1809 and closed in 1836. It was sold to The London & Croydon Railway, who used much of the route for its tracks, enabling it to open in 1839. The canal was not a commercial success; though it provided an attractive leisure facility ranging from swimming in the summer to ice-skating in the winter. Boating between its picturesque banks was very popular. A small portion of canal remains in Bett's Park as shown.

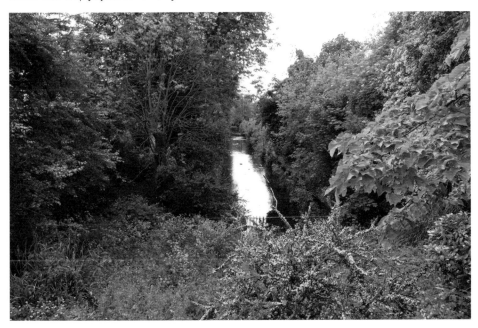

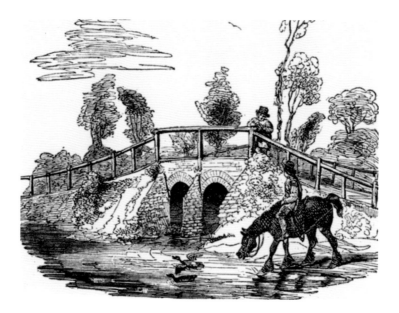

Chaffinch and Clock House Bridge

North of the present bridge at Clock House, the original Beckenham to Penge Road crossed the Chaffinch by the bridge shown in Samuel William's 1839 drawing. The artist accompanied William Hone on a ramble from Dulwich to West Wickham. The photograph is taken from where the old bridge stood. The course of the river is indicated in the foreground, and this is where the railway flooded whenever there was heavy rain. Modern engineering water control has now made flooding unlikely here.

Tilling Bus Beckenham Road, *c.* 1905

The Elm Road Baptist church is to the left and a Tilling bus is travelling towards Beckenham High Street, with cyclists able to ride safely two abreast. The transport firm, Thomas Tilling, started in 1847. It had horses stabled in Beckenham, and throughout the London area and suburbs. It continued into the motorised era; their first mechanically propelled bus running until 28 September 1904, replete with acetylene lighting and curtained windows. The curtains were soon discontinued. In 2014, public transport is even more evident as shown by the No. 358 bus, one of many routes along this very busy road. Kings Colleges of English are seen in the foreground. They are one of the educational businesses to carry forward Beckenham's long tradition in this field.

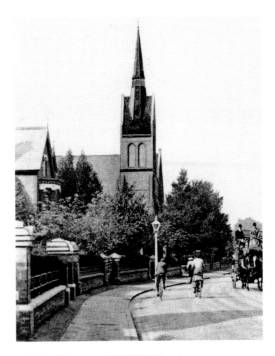

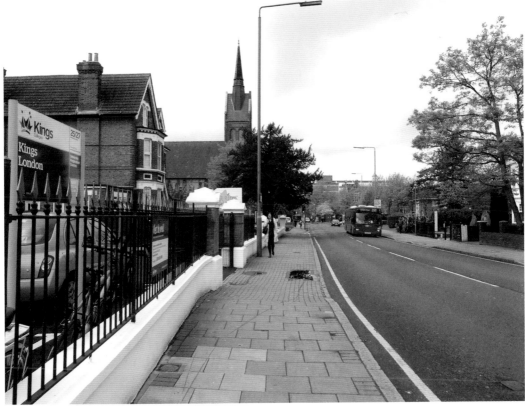

41

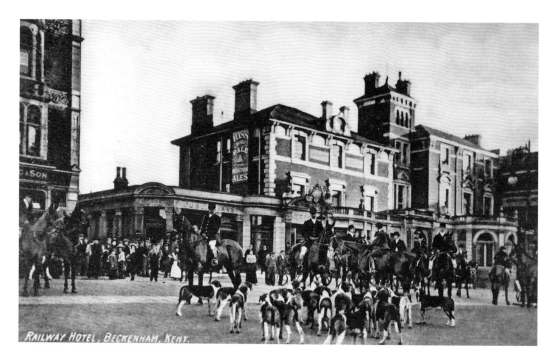

Station Hotel and the Green, *c.* 1905

The Hunt met here for the last time in 1905. By this time, there was little hunting country left in Beckenham, and so this tradition ended. The Hotel carried on until 1944, when two flying bombs devastated the area between here and St George's church. The green was created from the ruins and is now a village green, where activities such as markets add local colour. The shield of Beckenham – the town sign – may be observed at the centre of the old Station Hotel site.

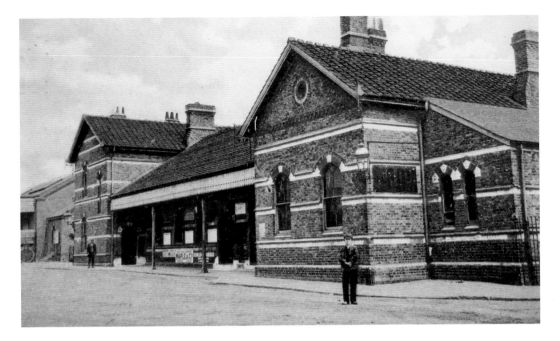

Penge East Station, *c.* **1900**

This well built railway station opened in 1863 and is situated in Beckenham, despite its name. The postal area designated this part of Beckenham as London, although it was administered by Beckenham. The beginning of the station's extensive goods yards can be glimpsed on the left of the old picture. The stationmaster had control of a large staff, and he even had power over the signalmen. The author can vouch for the fact that, in the 1940s and 1950s, he would order a fast train to stop for passengers when there was delay to the normal timetable. In 2014, there is a pedestrian-friendly road and path organisation. All the goods activities have gone, along with the large staff and prestigious stationmaster.

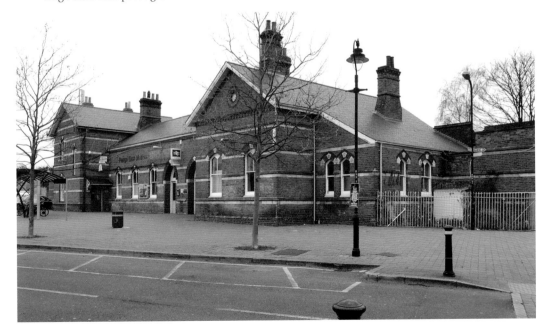

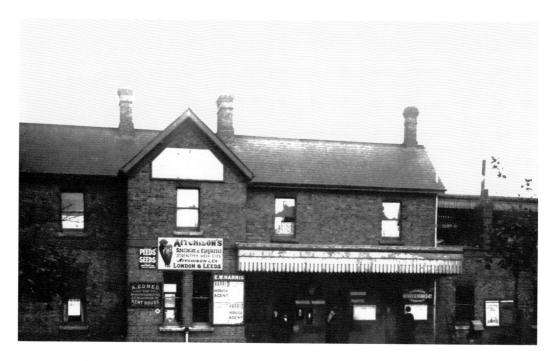

Kent House Station, *c.* 1900

The London, Chatham and Dover Kent House railway station took its name from the ancient nearby Kent House. The station was built in 1884 on land given by Albermarle Cator, on condition that it would only cater for passengers. There was to be no goods yard and that rule was kept. Eventually, four lines were built through the station. The station was opened here partially due to pressure from local residents who daily commute to the station was over stony, often muddy, un-metaled approaches. The road surface is the choice of residents of adjoining Barnmead Road.

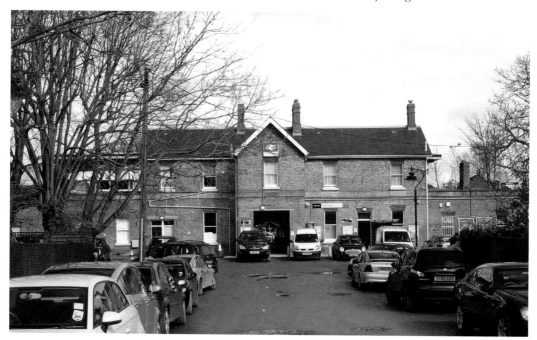

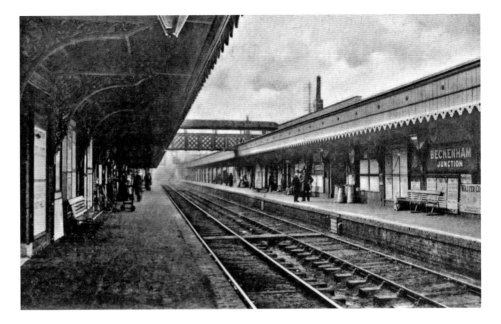

Beckenham Junction, c. 1900

When the train service started here on New Year's Day 1857, the village was about to be replaced by a town. The service on the Mid-Kent line was to London Bridge. The station was first called Beckenham and it was the terminus. In 1858, a line was extended from Crystal Palace to Beckenham, so it was renamed Beckenham Junction. In 1863, a more direct line through Penge Tunnel had made Beckenham Junction an even more attractive commuter destination. By 1861, the population was over 2,000, and had approximately trebled by the 1871 census. The railways were instrumental in boosting population growth. Note the milk churns in the old picture, and the same pedestrian bridge in both.

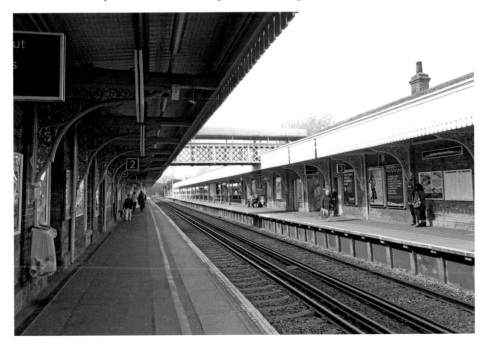

Birkbeck Station, c. 1933

The station opened in 1930 at about the time that even more houses were built in the vicinity. Before the houses were built at the corner of Mackenzie and Elmers End roads, the author was told by locals that there were performances of captive dancing bears, c. 1900. For many post-war years, the W. G. Grace public house stood opposite this corner, in honour of the best-known person buried in Beckenham Crematorium and Cemetery, which is adjacent to the other side of the station. This great cricketer's name was well represented in the pub, with examples of the games equipment dating from over 100 years ago, when he played at the Crystal Palace ground within Beckenham. The building is now a restaurant where Grace will be commemorated.

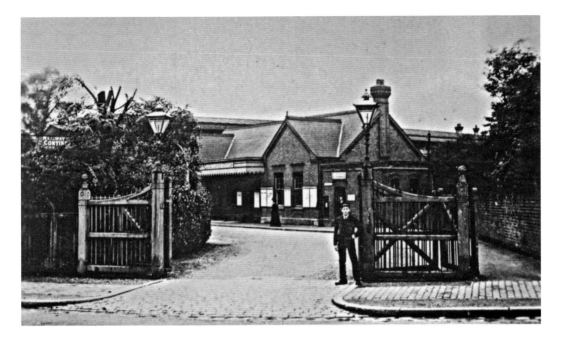

Shortlands Station, 1905

Shortlands station is in Beckenham, although right on the border with Bromley Parish. This station opened for passengers with the first train at 8.40 a.m. on Monday 3 May 1858. People gathered on Martin's Hill to see this unique occurrence looking down on the station, which at that time was a terminus called Bromley. The stationmaster received 30s a week, the clerk 15s and an engine driver 52s 6d in 1858. The stationmaster's house stood in what is now the forecourt, now car parking space, to the left of the 1905 picture. The route to Pimlico in London was then via Crystal Palace.

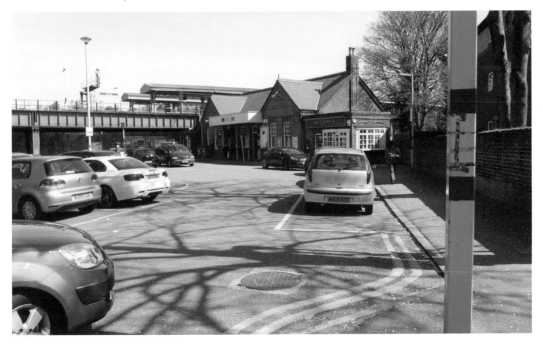

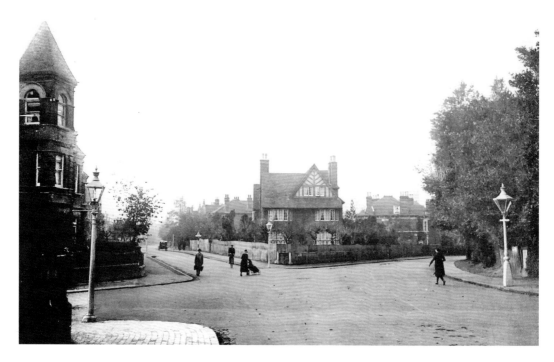

Crossroads Beckenham Theatre

The pictures show the Bromley Road and Wickham Road crossroads, looking towards Beckenham. The lack of traffic, when the old photograph was taken (*c.* 1911) allows pedestrians to walk on the roads. As motoring increased there was a high accident rate, as witnessed by the Beckenham Hospital annual report of 1912, which reported 1,026 casualties treated. The report comments on the increase from 285 in 1911. In the 2014 photograph, children are carefully shepherded across the road with the aid of traffic lights, near Beckenham Theatre Centre.

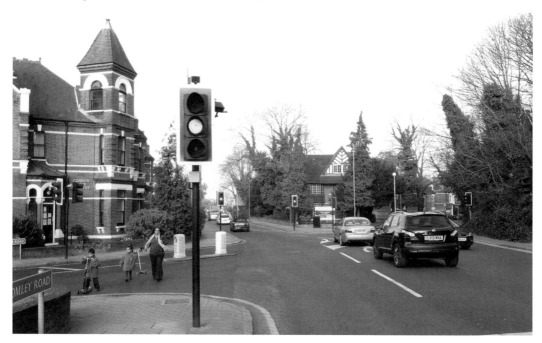

Schools

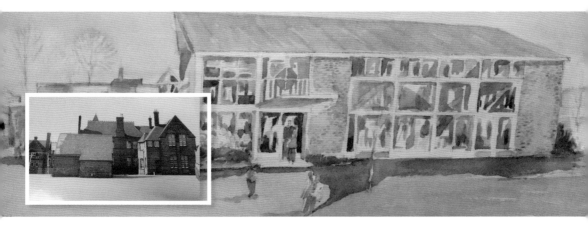

Alexandra Junior School, Cator Road

The painting by Tony Goodchild represents the school when it was opened in the late 1950s to accommodate the post-war increase of children. The school was earlier situated in Parish Lane, sharing a Victorian building with Alexandra Boys' School (*inset*). There were no grounds at the old site, whereas now there are 11 acres of playing fields. In September 2013, the school changed to academy status. In 2014, the school has a relaxed happy atmosphere, as perhaps reflected by the modern decorations.

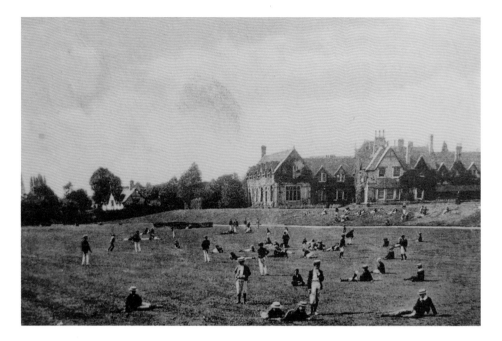

Abbey School, *c.* 1895

This building dates from the 1880s. It was modernised over the years, so that by the 1930s it had central heating, electric light, and facilities such as its own outdoor swimming pool. This boys' preparatory school had many distinguished ex-pupils, including a VC, a First Lord of the Admiralty and two Kent cricket captains. After evacuation in the Second World War, it did not return to Beckenham, and after a few years closed. In the 1970s, houses and flats were built over the extensive grounds, and only gateposts on the corner of Southend Road and Park Road remain.

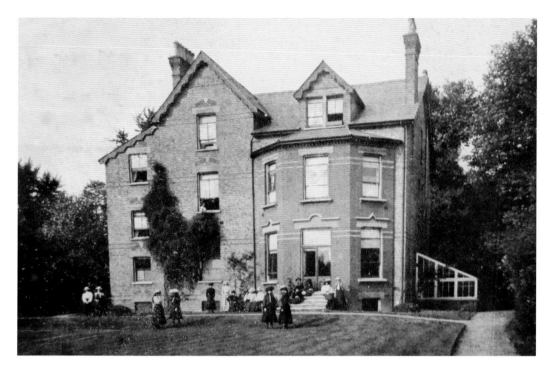

Minshul House, *c.* 1910

This school for young ladies was in Park Road opposite Abbey School. I have found no connection between the two schools. Minshull House Girls' School was founded in 1866, and therefore was one of the oldest schools in the area. During the Second World War, it was evacuated to Devon. The site was redeveloped in 1965 to become Minshull Place.

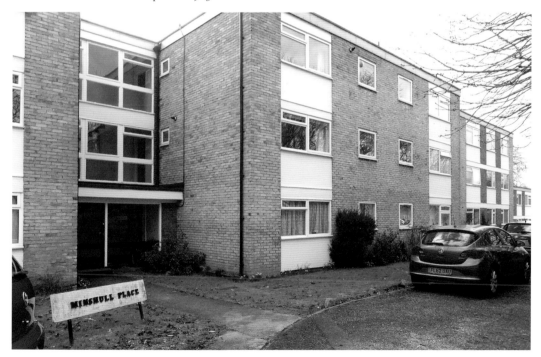

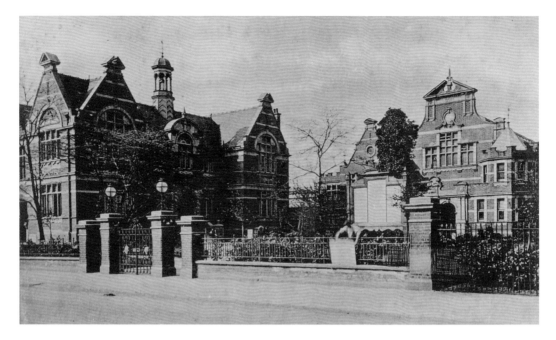

Technical Institute and Baths

Opened in 1901, the Technical Institute was one of the first in England and the only council provided secondary day school for miles around. Many travelled from the far reaches of what is now the London Borough of Bromley. The swimming baths were opened at the same time, and Beckenham introduced swimming lessons for schoolchildren. Perhaps that is why radio operator Bride, who attended the school shown, survived the Titanic disaster. The old baths produced many Olympic swimmers, such as Duncan Goodhew. Let us hope that the modern 1999 swimming facilities provided by the Spa do the same for future swimmers.

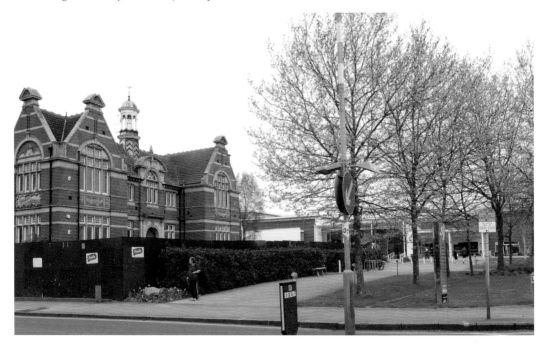

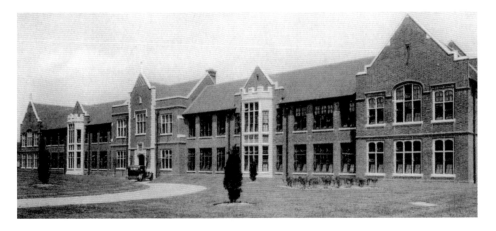

County School for Boys, 1935

Formerly the school building, next to what is now the Spa, it provided secondary education for boys. The staff and boys of this school moved to the Penge High Street site in January 1931. The new headteacher was Mr Sidney Gammon, who had a distinguished war record and was a history graduate from New College, Oxford. The school prospered under his leadership, but in 1940 he was killed, with his wife and son, at his home in Foxgrove Road Beckenham. The school, later called Beckenham & Penge Grammar School, moved again in 1968 to Langley Park, and this building became Kentwood Secondary Boys' School. In 2014, the building is, at the photographer's end, Harris Primary Kent House and at the other end, Kentwood Adult Education Centre.

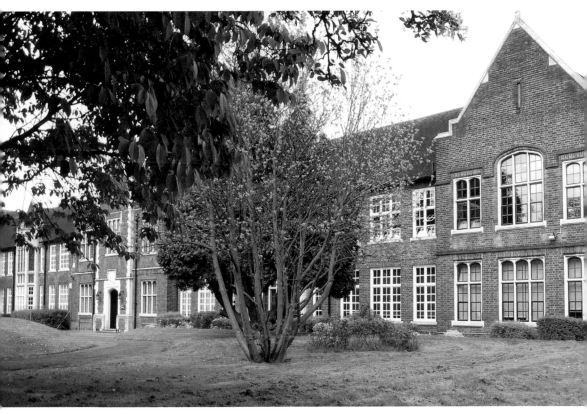

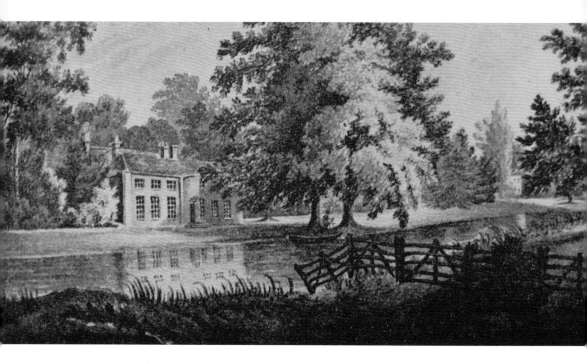

Langley, c. 1820, and Langley Schools

The mansion of Langley, seen in the old picture, burnt down in 1913. In the 1960s, Langley Park School for Girls and Langley Park School for Boys were built on part of the old mansion's grounds. The 1960s school for boys was constructed with a large area of sports field separating it from the girls' school. The boys' school, shown here, is now only a few yards from the girls' school. The new rebuilt boys' school was a working school in 2012, and was honoured with a royal opening by Prince Edward, The Earl of Wessex, in 2014.

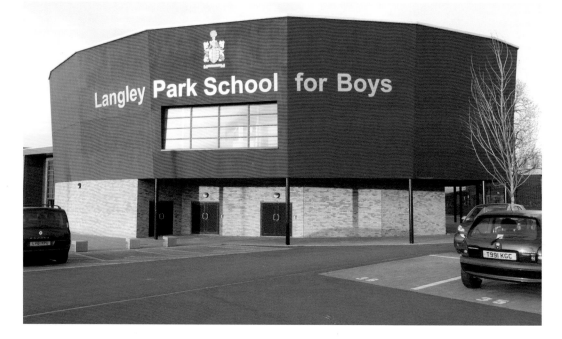

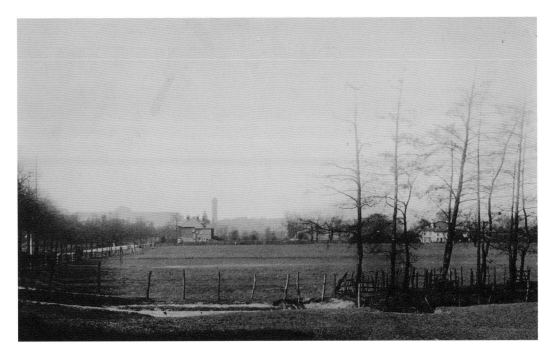

Lennard Road, *c.* 1905, Later Harris Academies

Until 1905, the area had received little development, so Kent House Farm is still visible across the stream and fields. The Crystal Palace can also be seen in the distance. In 2014, the same view is not possible because of development, including the mixed Harris Academy School in the foreground. The early twentieth-century building on the left was first used as a hospital in the First World War, before it was used for its intended purpose as the County School for Girls. It is, in 2014, also a Harris Academy mostly for girls, however the sixth form is now mixed.

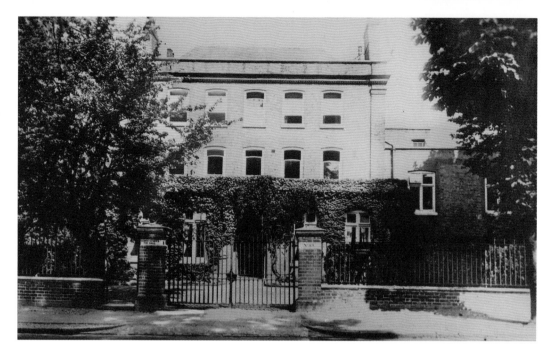

St Christopher's, The Hall School, *c.* 1926

The school was founded in 1893, moving several times until it was housed in The Hall, Bromley Road, in 1926. The house was built in the eighteenth century, and Peter Cator was in residence until he died in 1873. The most famous pupil of St Christopher's School for Girls – for ten years – was the author Enid Blyton, who was head girl from 1915 to 1917. The school is now a kindergarten and preparatory school for boys and girls, up to eleven years of age. A widened pavement has been constructed recently to aid safer crossing for the children.

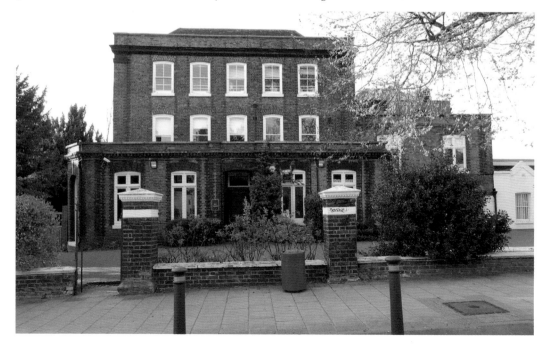

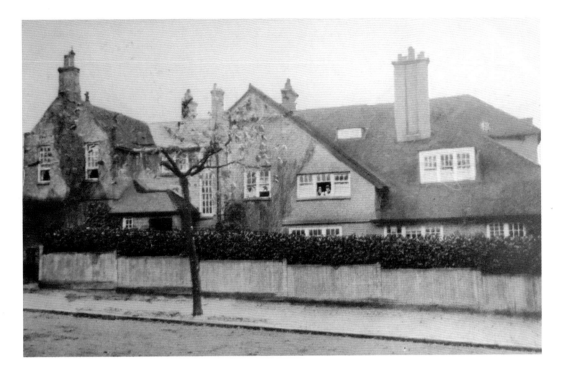

Clare House School, c. 1935

Clare House was a private boys' school from 1896 to 1970, where pupils were prepared for public school or the Royal Navy. It was a boarding and day school, however, by 1970, it had to close for financial reasons. The local authority demolished the old buildings and built a new primary school on the site. It opened in 1976, adopting the name Clare House.

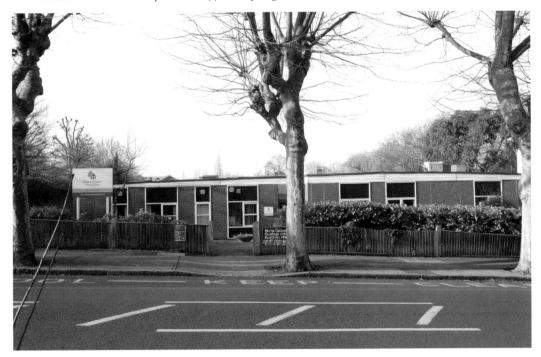

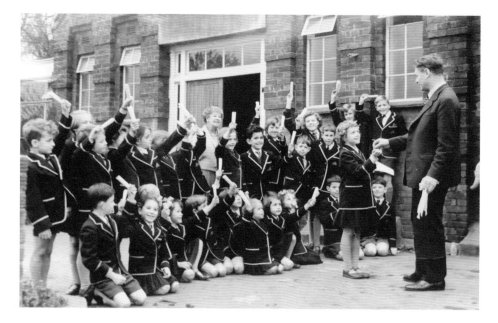

St David's College

The school was established in 1926 by the first principal Mrs G. Davies, a graduate of Cardiff University. Welsh heritage therefore influenced the choice of name, with the addition of 'college', fashionable at the time. Mrs Davies was fortunate to have the advice of many Welsh professor friends, which ensured that the latest methods of teaching were successfully applied. The preparatory school gathered a good reputation and increased its numbers, so that an adjacent building, Justin Hall, was purpose-built and opened in 1933. The principal, Dr D. Schrove, is seen in the picture making a presentation to children for their success in the Beckenham Festival in 1956. The young girl receiving the presentation is his daughter, who is the present principal, Mrs A. Wagstaff. On 1 April 1934, the ceremony was held outside Justin Hall, signifying the absorption of West Wickham into the Beckenham administrative area.

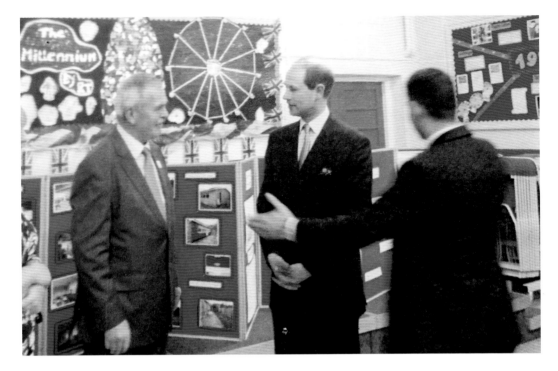

Stewart Fleming Primary School
HRH Earl of Wessex unveiled the newly refurbished teaching block on 14 January 2010. The school opened in 1940, so this was also its seventieth anniversary celebration. The new block was fitted with the latest technology, and was named after John Pepper, who is to the left with Prince Edward and the headteacher Mr Lee Mason-Ellis. The John Pepper Block is pictured in 2014.

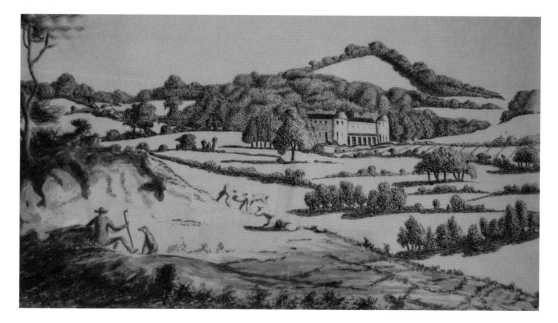

Shortlands House, *c.* 1800, Bishop Challoner School

This late eighteenth-century house is a Grade II listed building. George Grote, the historian, was born here in 1794. He was also an MP and introduced the 1832 Ballot Bill, which became the Great Reform Act of 1832. Despite refusing a peerage, when he died in 1871, he was buried in Westminster Abbey. W. A. Wilkinson MP later lived here and sold 136 acres of his grounds as building plots in 1863, at £500 an acre, a very high price reflecting the area's desirability partially resulting from the arrival of the railway. Shortlands House was a hotel until 1949, and then a school from 1950. In 1958, it became a boys' grammar school, named in honour of the eighteenth-century Catholic Bishop Richard Challoner. It is in the parish of St Edmunds in Beckenham and, in 2014, it caters for boys and girls from infants to eighteen-year-olds.

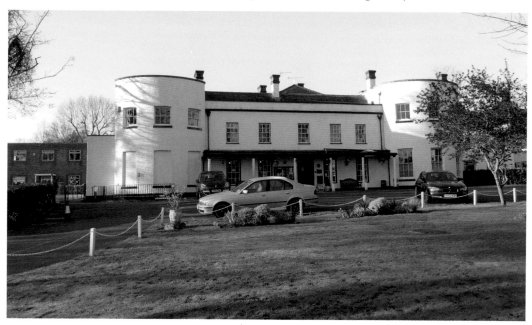

Roads

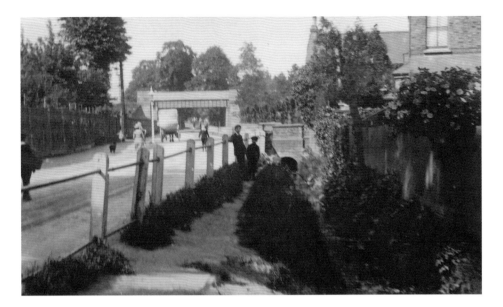

Boundary Stream, *c.* 1910
This stream once formed the border between Surrey and Kent. In 1900, the Penge Council opted to be part of Kent. However, in my father's generation, around the First World War, local boys still fought inter-district mock battles – Penge against Beckenham – along this stream. The stream was later covered so that Kent House Road now has a wider pavement with the water hidden below. The new picture shows perhaps too much parking, but the same railway bridge.

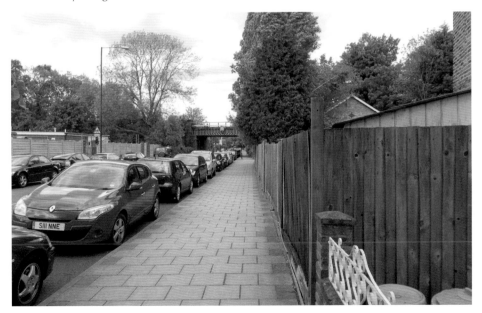

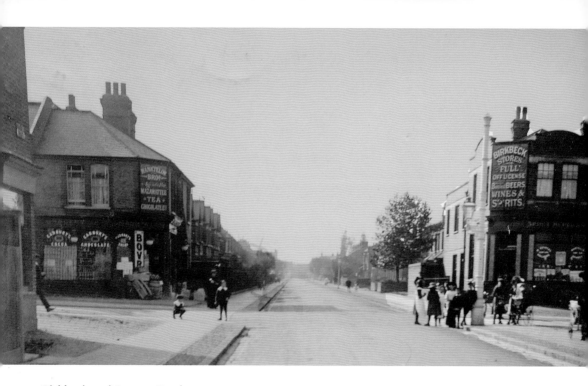

Birkbeck and Avenue Roads, *c.* 1905
In the image above, the children relax with no fear of fast traffic. There is a general grocery store on the far left corner and an off licence on the right. The latter survived into the late twentieth century. The corner shops at this junction have now gone. Visible to the right of the modern picture is Avenue Baptist church; all the local roads now have speed bumps and a 20 mph speed limit.

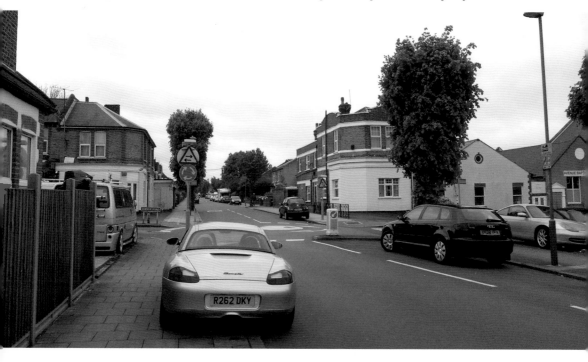

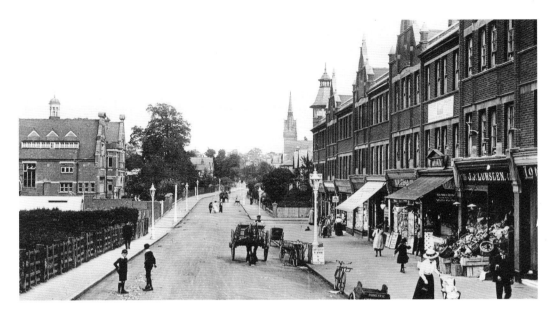

Clock House Bridge, c. 1904.

The new technical institute is shown below the bridge to the left. It opened in 1901. The wooden fence served this function until well after the Second World War. To the right, the greengrocer operated until 2003, and now a glazing business operates on this spot. The casual and leisured use, in the earlier image by the Eton-collared school boys and other pedestrians standing in the middle of the road, contrasts with the photographer dodging much traffic in 2014.

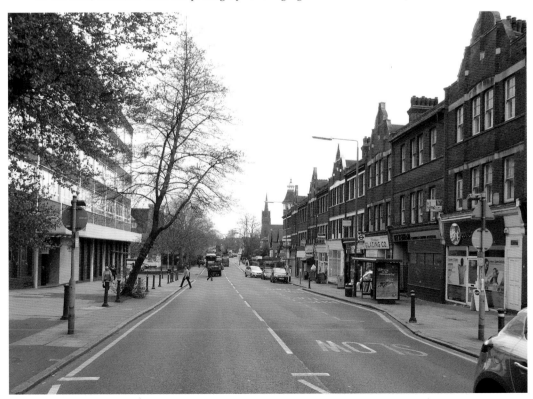

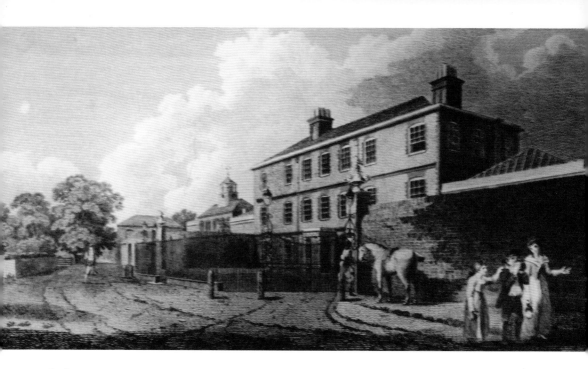

Clock House, *c.* 1822

The house was built in the early eighteenth century. Sir Percy Brett, Admiral of the Blue, lived there in the mid-eighteenth century. When the artist James Edwards produced this picture, Joseph Cator was in residence. Notice that the road to Penge bends to the right in the old picture. When the railway bridge was built, the road was straightened, as shown in the 2014 photograph. The technical institute of 1901 was built exactly where the mansion stood.

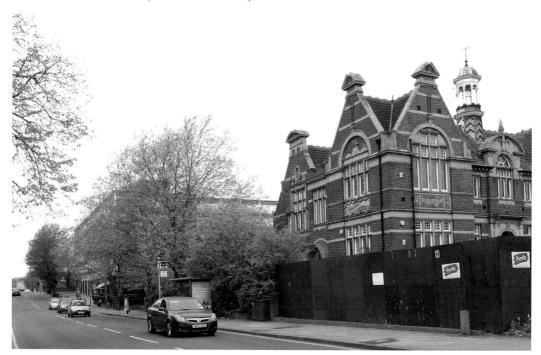

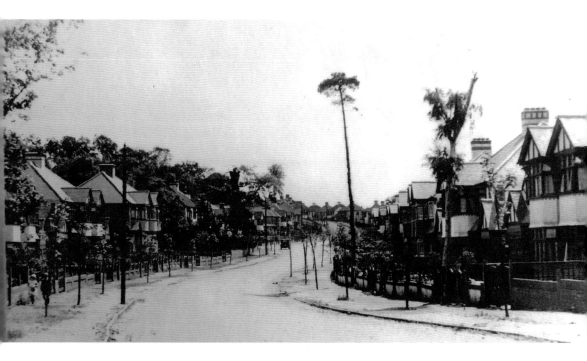

Village Way Beckenham, *c.* 1935

This road is typical of housing development in Beckenham. In the early twentieth century, there were a few dwellings in a short road and, by the mid-1930s attractive, well built, detached and semi-detached houses lined the new through road. Additionally, the road has two parks and is convenient for the High Street. The increase in car ownership is evidenced by the two pictures.

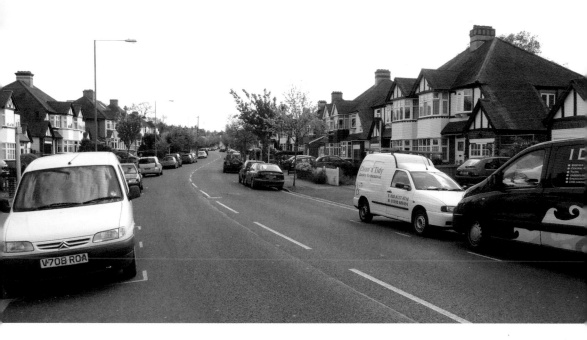

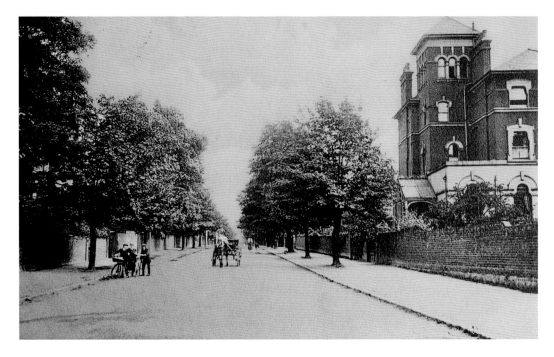

The Avenue from Southend Road, *c.* 1900

The very large houses of 1900 Beckenham, with accommodation for many servants, have mostly been replaced by flats or smaller houses. The 1900 house and large garden seen here have been supplanted by Beckenham Court, where dozens of commuters are within two minutes of the station. The errand boys seen in the old picture received about 1*s* 6*d* to deliver fresh provisions. A cook in one of the old large houses was one of the best paid servants, at £15 a year.

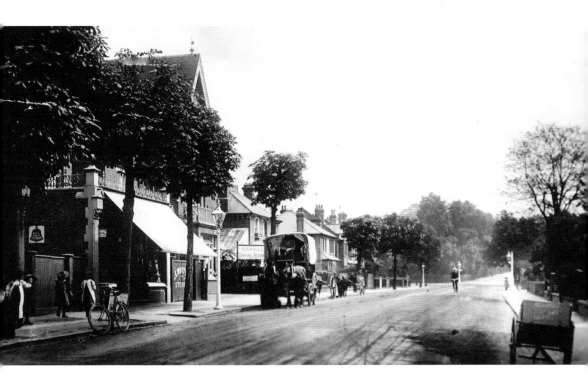

Bromley Road, *c.* 1905

The chemist working under the name Peters is visible in the 2014 picture. There was a bakers by this name on the opposite side of this road in 1905. Advertised on the left are dining rooms. The handcart on the right is typical for this time, mostly moving heavy goods. The semi-rural scene in 1905 has yielded to a more urban area today, with many flats and nursing homes.

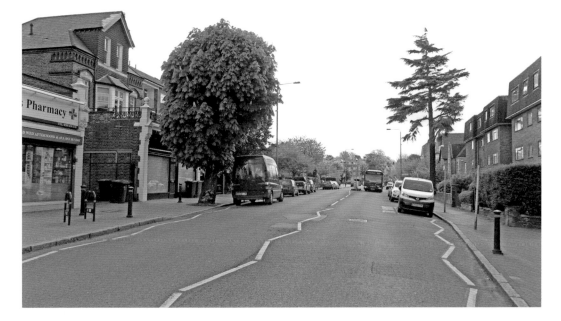

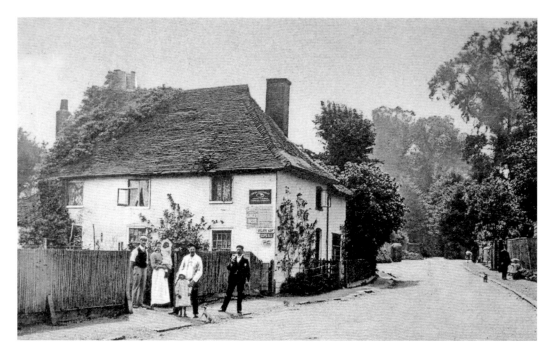

Old Cottage, *c.* 1905

This nationally listed Grade II, sixteenth-century, wooden frame cottage is a landmark to drivers approaching the Chinese garage along Wickham Road today. Earlier it was a destination for cyclist in a tranquil setting, so the signs on the wall read Cyclist Best, Whites Ginger Beer and other items to tempt the passer-by. In the distance, the gates of Langley Court are just visible in the old picture; however, in 2014, fences obscure the view. Only three roads met here in 1905. Now there are five busy roads at this junction.

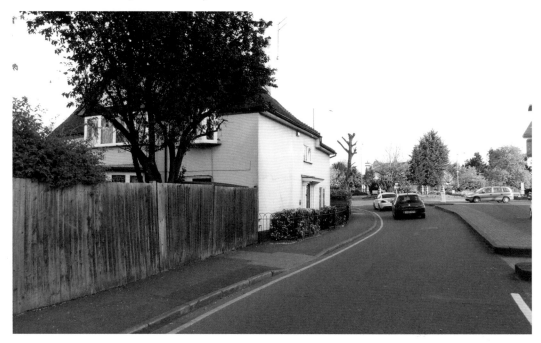

War

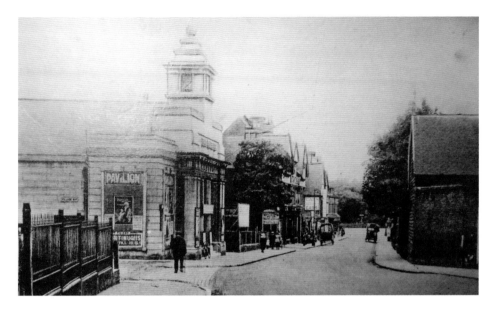

Pavilion Cinema, *c.* 1914, Militia Drill Hall
This was Beckenham's first cinema, opening in October 1914 with patriotic propaganda films. When the Regal Cinema opened nearby, in 1930, the Pavilion was no longer viable. The regal building is now the cinema complex near the war memorial. The Pavilion Cinema replaced Elm Cottage, which was the Volunteers' or Territorials' centre up to early 1914. The Volunteers were renamed Territorial Force in 1908, and moved to Parish Lane when Elm Cottage was demolished in 1914 to make way for the Pavilion. Part-time soldiers went off to both world wars from this purpose-built drill hall or TA centre.

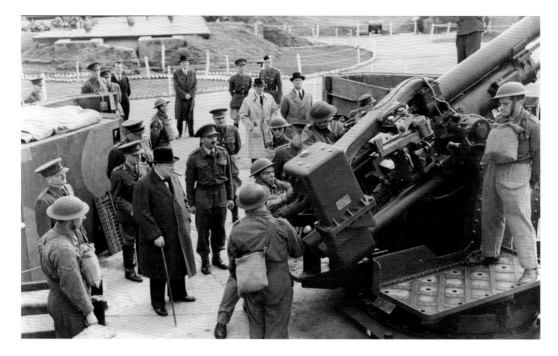

Churchill Inspects Beckenham Guns

From 1935 to 1945, the Elgood playing fields hosted the latest heavy anti-aircraft guns. PM Winston Churchill is shown making an inspection here, in October 1941. The guns were 3.7 inch calibre, and the most modern British heavy anti-aircraft weapon. According to local war historian Gordon Dennington, the guns were earlier stored and supplied from the Royal Artillery, TA unit, Bromley Road Catford. The Elgood site was developed later as Kelsey Park school, and is now Harris Academy, Beckenham, who are thanked for their help. Paradoxically the Beckenham and Penge Maternity Hospital, Stone Park Avenue, was adjacent to the gun site and functioned throughout the war. Those I have met born here, during the war, seem fine to me.

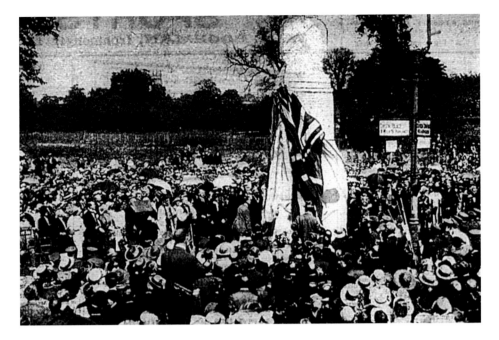

Beckenham War Memorial, 1921

The war memorial opening ceremony is conducted against a semi-rural backdrop in 1921. The rectory grounds originally stretched down to the point where the Regal Cinema opened in 1930. Later, the cinema was called The ABC, and is now the Odeon. Christ church spire is just visible in both pictures. The war memorial illustrates how badly the district was bombed in the Second World War, showing that more civilians were killed than servicemen. Civilians named on the memorial are: 164 men, 144 women, and 22 children – some sadly known to the author.

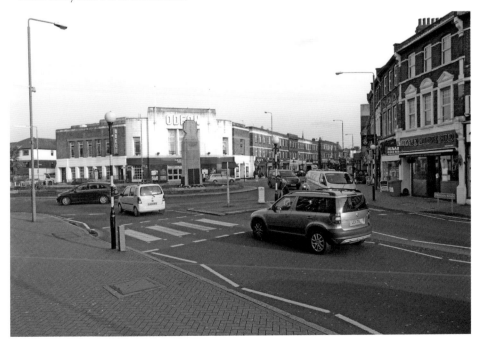

St Georges Road, Beckenham, *c.* 1930

Well-built middle class houses lined both sides of this peaceful road in 1930. On 2 July 1944, a flying bomb (V1 or drone) damaged this road followed by another on 28 July, which devastated this road and the area stretching to the High Street. In total, six people were killed and fifty-eight injured. The houses and businesses were never rebuilt and, to the right of the road, a car park has been established. On the left, the pleasant Beckenham Green now commemorates the victims.

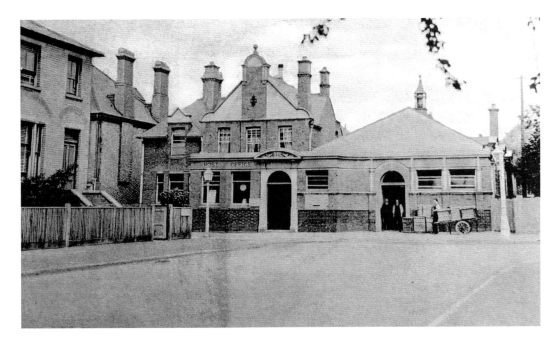

Post Office, Albemarle Road, c. 1899

This purpose-built post office opened in 1897, and served Beckenham until 1939 when the new premises opened at the junction of Beckenham and Rectory Roads. From 1897–1939, the sorting and delivery of mail was handled in Albemarle Road. The frequency of collection and delivery was such that an evening meeting could reliably be arranged locally within one day. The postmen worked on Sundays, and sometimes had split duties in their weekly schedule, typically 5 a.m. to 9 a.m. and 3 p.m. to 7 p.m. Their pay was from 18 to 30s a week, depending mostly on the number of years they had served. Albemarle Road has changed its shape and location, so that the building of 1897 would be approximately 10 metres back from the buildings shown facing St Georges Road in 2014.

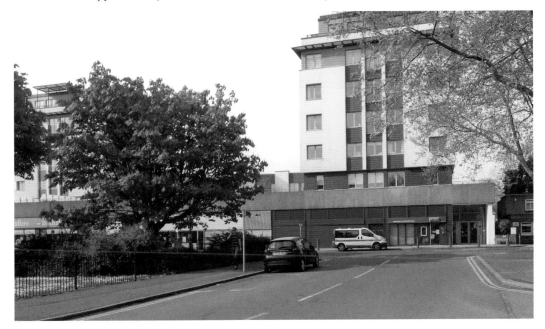

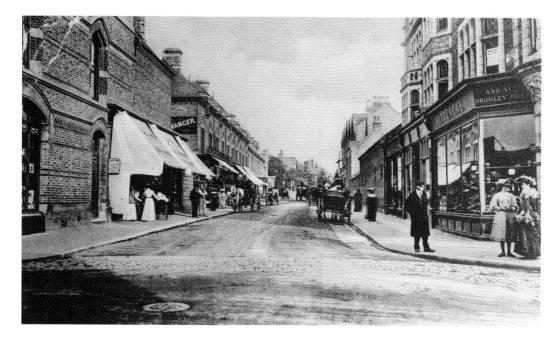

Albemarle Road Beckenham, *c.* 1900

The bustling shopping scene, with at least three coachmen busy with their employers' coaches, can be seen in the first 100 yards of the old road. Elegantly dressed people were attracted to this area, then rich in shops and businesses, including the main post office. The old road was situated to the north of the present road, and would have had its south side where the kerb appears near the estate agents in the 2014 picture. Two flying bombs destroyed the whole area from here to St George's church; however due to this Second World War disaster, Beckenham Green now graces this central area.

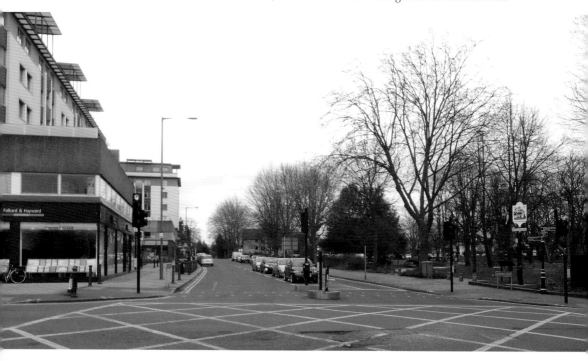

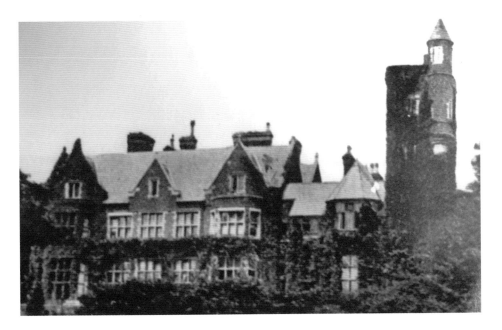

Oakwood

Oakwood House was used by one of the military transport divisions in the First World War, when this picture was produced. The house, standing on some of the highest land in Beckenham, was also called Clay Hill and Oakery. Notable people have lived here, including Dr Scott; this is why nearby Scott's Lane is so-named. Gary Lineker, the footballer, had an ancestor who worked as a gardener on this estate. The owner, the historian Edward King, paid for his gardener's son to attend the Blue Coat School, then in Newgate Street in the City. The lawn of the house in Ashmere Avenue, shown in the modern picture, still has the tennis court only a few inches below the surface. Ashmere Avenue follows the line of the drive leading to the site of Oakwood House.

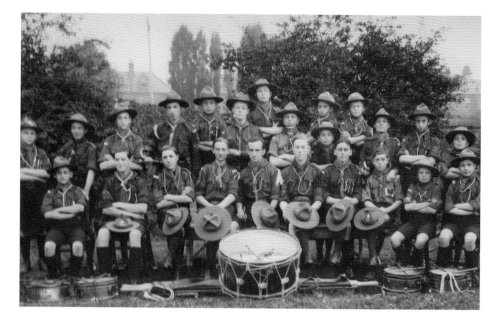

Scouts, *c.* 1912

The YMCA scouts proudly pose near Holy Trinity with their musical equipment. The houses in the background are in Lennard Road. They enjoyed a summer camp in Belgium in 1912, not knowing what horrors awaited many of them in that country and France. The central adult figure is George Johnson, who returned injured with a nervous disorder and died in 1922. His death was not counted as a war death, but was caused by the war. The troop was later called the 12th Beckenham.

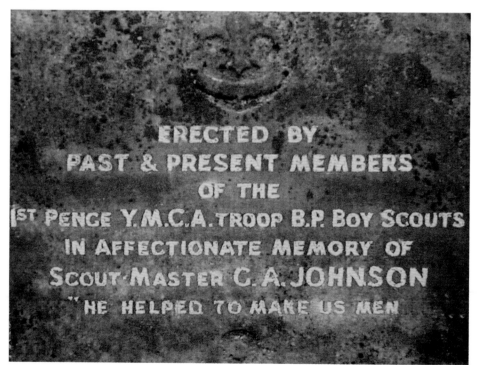

ERECTED BY
PAST & PRESENT MEMBERS
OF THE
1ST PENGE Y.M.C.A. TROOP B.P. BOY SCOUTS
IN AFFECTIONATE MEMORY OF
SCOUT-MASTER G.A. JOHNSON
"HE HELPED TO MAKE US MEN"

C/Sgt Bourne of Rorke's Drift, and King's Hall Road

Honorary Lieutenant Colonial Frank Bourne eventually retired from the army in 1918, having attained a higher rank than the 1879 Rorke's Drift leading VC heroes, lieutenants Chard and Bromhead. Many people will remember this battle from the film *Zulu,* where Nigel Green played the character of Col. Sgt Bourne. Frank Bourne lived for two decades of his retired life at No. 16 King's Hall Road, and is buried with his wife at Beckenham Cemetery. At the Blue Plaque ceremony in 2001, the great grandson of the Zulu Chief, Cetewayo, and the grandson of Frank Bourne stood next to each other. The ceremony included a representation of the South Wales Borderers, seen against a backdrop of the neighbouring 1880s Syme and Duncan King's Hall Road houses.

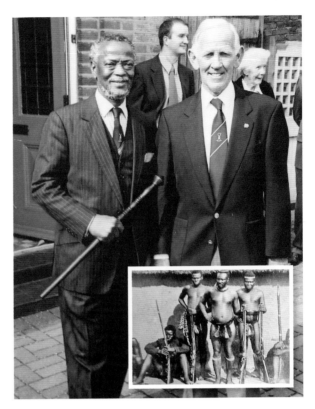

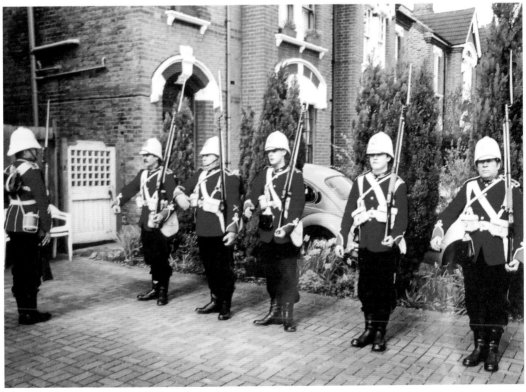

Churches

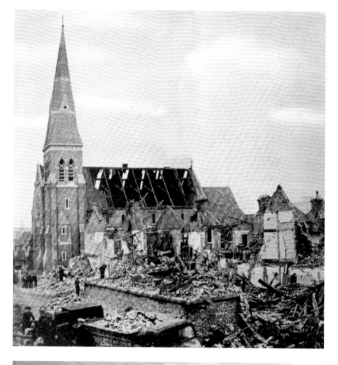

Christ Church, Beckenham
On 5 January 1945, the last flying bomb to hit Beckenham, badly damaged Christ church, and destroyed twenty houses in Fairfield Road. The large car parks that exist today show the area of total destruction. In the First World War, the halls of this church were converted into a hospital, first treating Belgian, and later British, wounded soldiers.

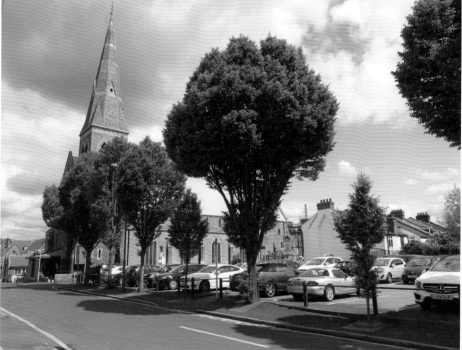

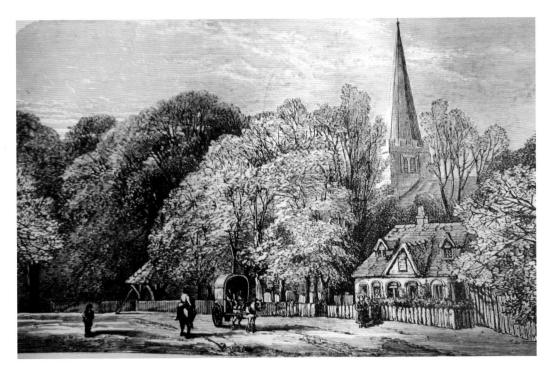

Rawlins' Almshouses and St George's Church, _c._ 1700

Anthony Rawlins was a wealthy London merchant, who died in 1694 while staying with the Lethieulliers at Kent House. In his will he left £50 for the use of the poor, and the three attractive almshouses near the church were built as a result. The houses have been enlarged and improved, and are administered by Beckenham Parochial Charity. St George's church in Beckenham is the original parish church. Until the nineteenth century, this was the only church serving the whole of Beckenham and the Penge area.

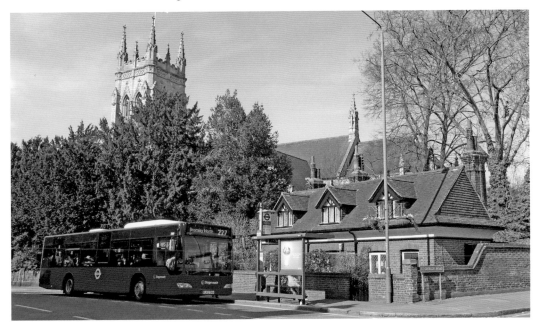

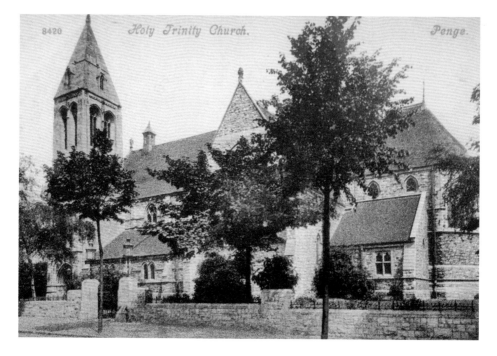

Holy Trinity, *c.* 1900

This large church was built in 1878 mainly by the generosity of Francis Peek, a tea merchant and member of the Peek Freen & Co. biscuit company. It stands in Lennard Road with a Penge postal address, however it lies within the Beckenham parish. In 1994, arson badly damaged this beautiful church so that only the tower remained virtually undamaged. The remainder had to be rebuilt as shown. The transformation has been tastefully accomplished, and the building caters for all ages. Youth organisations, such as Scouts and old peoples' meetings, serve the community well.

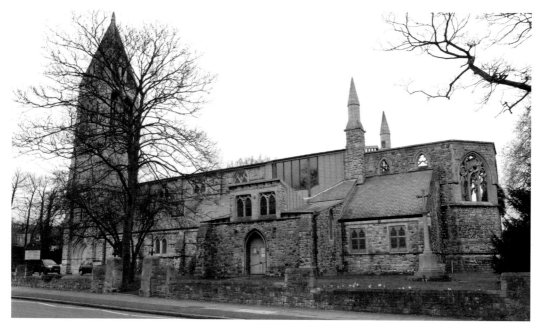

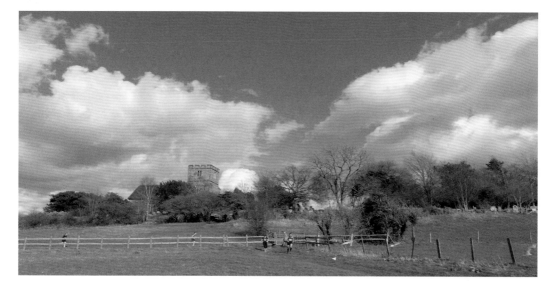

West Wickham Church

The church was recorded in Doomsday, and was rebuilt in the fifteenth century. A settlement existed here in Roman times as a staging town, Noviomagus. The remains of the London to Lewes Roman road runs near where the recent photograph was taken. Signs of the road can be found right through West Wickham and Beckenham. The fourteenth-century Black Death more than halved Beckenham's population, who apparently left this rural scene and moved to the next hill. The scene here shows Blackheath and Bromley Harriers, on one of their cross country races, which normally use the church vicinity as a starting point. Sydney Wooderson, who lived in Village Way Beckenham, is their most famous past member, holding the pre-Second World War record for the mile. The club headquarters, on the border of West Wickham, is now called the Sydney Wooderson Centre.

The Sydney Wooderson Centre

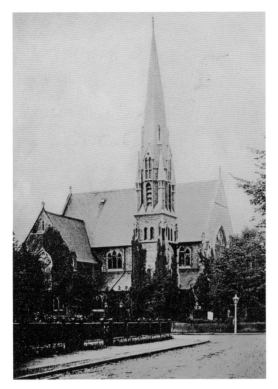

Beckenham Congregational Church, c. 1900

The church building with the spire was opened on 13 July 1887. However, the first church construction, a lecture hall at the back of this building, was opened on 25 April 1878, and later used as the church hall. The latter was destroyed by bombing in 1941, and a new hall was built on the site and opened on 4 March 1950. This building now serves as the main United Reform church, since the large church was recently sold for residential development. It was converted into twelve apartments called 'Spire Court'. One large apartment was sold in 2014 for over £900,000. Note the new fire escape crossing to the spire.

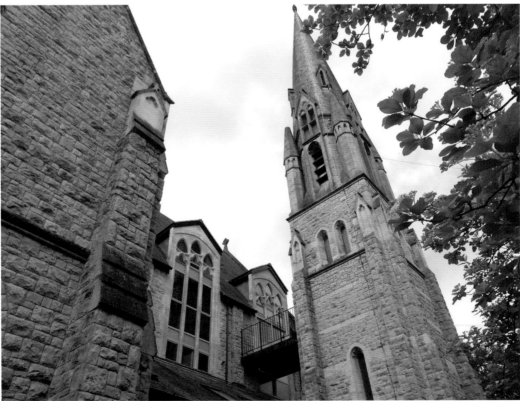

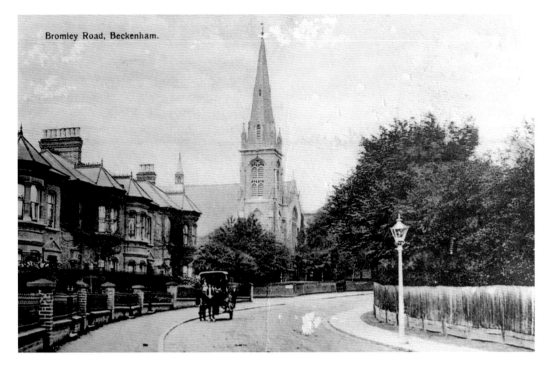

Bromley Road, Beckenham.

Bromley Road Methodist Church, c. 1905

The church was opened on the corner of Bevington Road in 1887. There was some bomb blast damage in the Second World War, which may have contributed to the damage causing the removal of the spire in 1981 for safety reasons. There are many social and sporting activities, and clubs meeting here, along with strong Scout and Guide organisations.

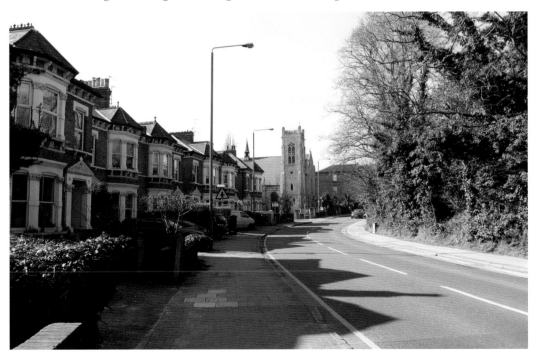

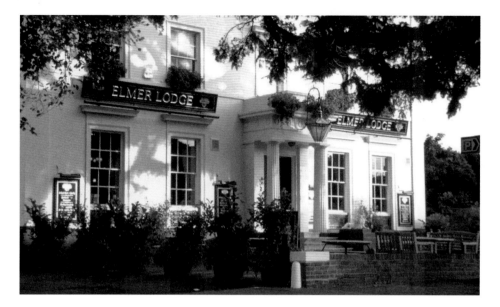

Elmer Lodge, Now Coptic Church

This building, like many in Beckenham, was originally an upmarket residence. Craven College moved here from Beckenham Place in 1905. What is now the Beckenham Rugby Football ground was the Eden Park Polo Ground used by the school. Its fortunes ended around 1914. For many years, Elmer Lodge was a club and pub; now it serves the Coptic community of this part of England. Church members are mainly professional people ,and the church is most active at weekends. Members are proud that their church traces its origins to St Mark's visit to Egypt in AD 70. Interestingly, one of the languages used to study the Bible is Arabic. At one time, the use of the Coptic language in Egypt was punishable by cutting out the tongue.

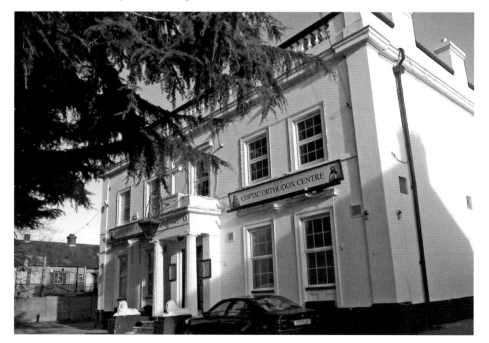

Industry and People

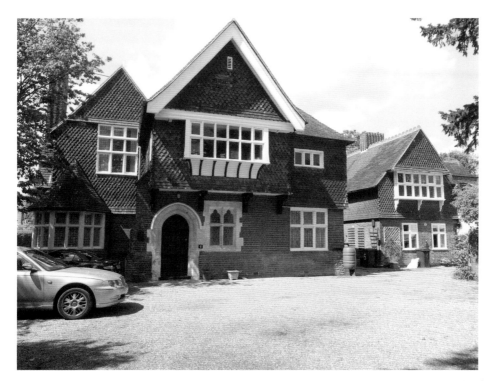

Shortlands Road, the House of Mrs Craik

Mrs Dinah Craik and Enid Blyton were both famous within their eras, and both lived in Shortlands Road. Mrs Craik was a Victorian author, whose best known work was *John Halifax Gentleman,* which was published in 1857. This was a favourite present from aunts to teenage nephews, who were encouraged to emulate the hero and become a gentleman. Less than a 100 years later, Enid Blyton was producing stories that were more popular than those from her 'neighbour', Mrs Craik, who lived and eventually died in 1887, in this the Corner House. She was buried at Keston Churchyard.

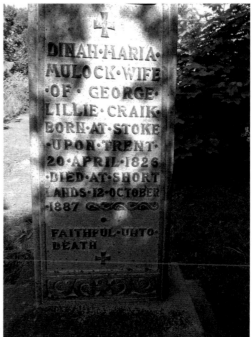

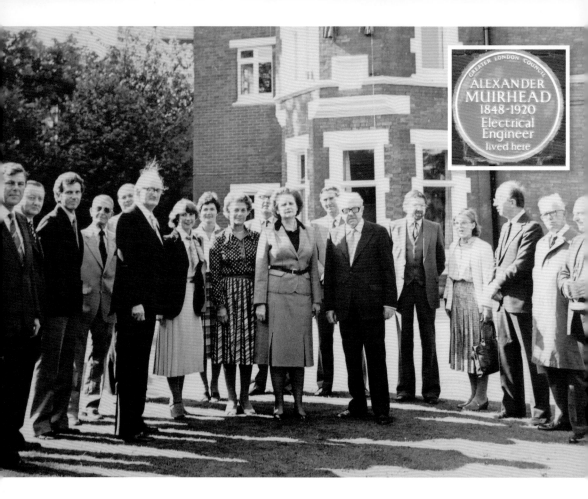

Muirhead

The Greater London Blue Plaque was unveiled to Alexander Muirhead at the Lodge, Church Road in Shortlands, in October 1981. The address is Shortlands Bromley; however most of Shortlands is in the historic Beckenham parish. Alexander Muirhead gained his Doctor of Science qualification at St Bartholomew's Hospital, London, where he recorded the first ever electrocardiogram. His firm provided X-ray equipment to Beckenham Hospital in 1902, probably the first local hospital to have such equipment. One more recent invention and manufacture was for ship stabilisation systems, which catered for many of the world's needs. The Muirhead factory continued after his death in 1920, and the factory at Elmer's End expanded to cover most of the vast area that the Tesco store has since replaced. There are many other ex-Muirhead sites in Beckenham. Locally there remain only certain elements at Muirhead Aerospace in Penge.

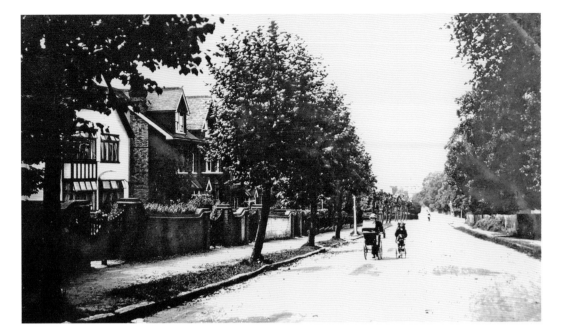

Oakwood Avenue, c. 1905

The large well-appointed houses, many of which had 'live in' servants up to the Second World War, still lacked hard surface paths in 1905. On the right of the picture, there are no houses, and behind the fence the old grounds of Oakwood House still presented a rural scene. To the left of the photographer is No. 34 Oakwood Avenue, which would later house Enid Blyton. The woods featured in some of her stories are based on Oakwood, opposite the house that is now built over, as seen in the 2014 picture. The arrow visible on the road surface points to White Oak Drive, which is a late 1960s infill development on what was Oakwood House parkland.

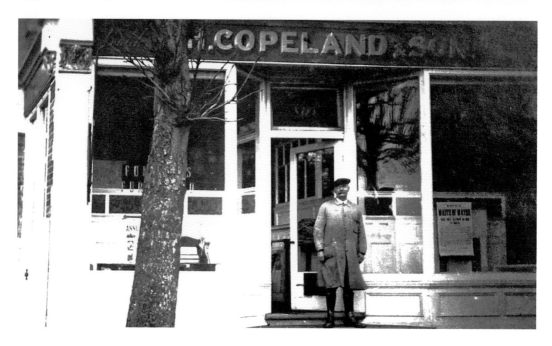

Copeland Builders and Undertakers, *c.* 1900

Henry Copeland arrived in Beckenham from Sleaford, Lincolnshire, in 1862. This was a time when many were migrating into places like Beckenham, aided by train transport. In 1885, he established his business at what is now No. 9 Bromley Road, with the then usual combination of builder and undertaker. His sons, and eventually his grandson, H. Rob Copeland continued the business, which eventually became undertakers, from the same premises until he retired and the firm was sold. The name has been retained, as shown in the 2014 picture. Rob Copeland wrote a number of good books on local history.

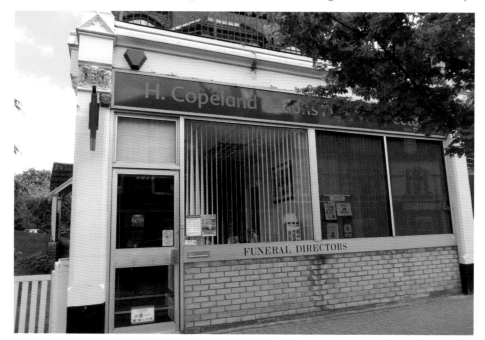

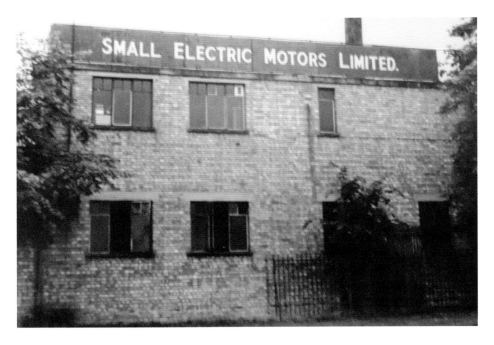

Small Electric Motors

There was much industry in the twentieth century locally, especially in the western and north-west borders of Beckenham. It has now mostly attenuated, or moved to other locations. This applies to factories such as Muirhead and Small Electric Motor Ltd (SEM), who each employed hundreds of mainly local people. Both factories produced supplies for the armed forces during the Second World War. SEM had several factories, the one shown was their main location adjacent to Churchfields Recreation Ground. Housing, in Florence and Gresham Roads, has replaced the factory site. The two roads connect Churchfields Road to the recreation ground; from which both photographs were taken.

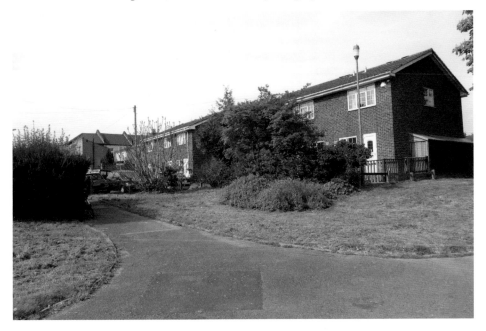

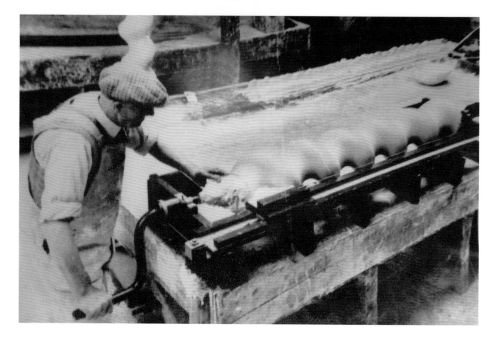

Tomei Workshop, *c.* 1925

The skill of working with plaster is learnt over many years and the first photograph shows an unknown man in the same workshop. These premises, next to Penge East station, have served the company for nearly 140 years. Raffaello Tomei, and his uncle from near Lucca, Italy, set up this this firm in 1875, first selling religious statues and later plaster decorations. Mick Anderson, in the 2014 picture, is now the foreman of this business. In his final apprentice year (1981) he was top qualifier and won the Golden Trowel from The Plasterers Co. in the City of London. The firm is contracted to reform and maintain plaster work at Harrods, as well as bespoke work elsewhere.

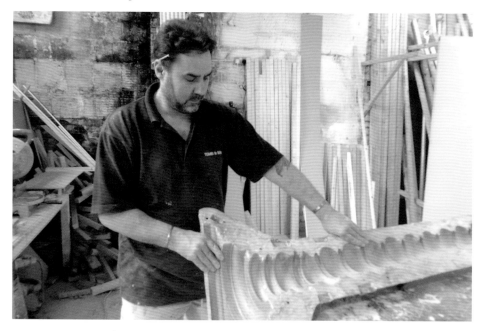

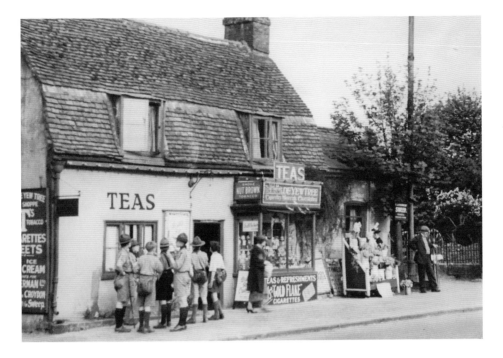

Glebe Way Scouts, *c.* 1933

After their refreshments, the Scouts may have hiked down a path that went in the direction of the post-war Glebe Way. The path constituted the fourth route in the description Norwood Cross, which was the name of this meetings of the ways. Wickham Court Road is to the right, and Station Road is to the left of both photographs. The building in the earlier photograph has been sacrificed to the demands of ever increasing traffic.

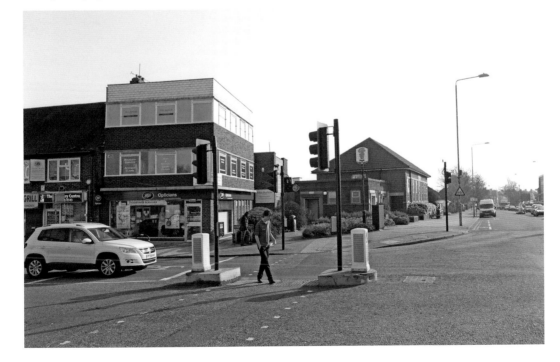

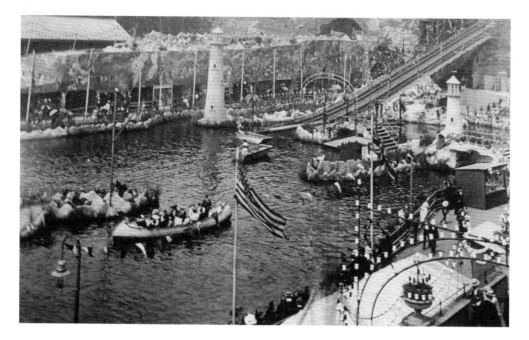

Crystal Palace, c. 1911

Beckenham had a border near where the BBC transmitter tower is today. One third of the Crystal Palace grounds were in Beckenham. Swimming races were held in the water, seen in the old photograph. Early in the twentieth century, the reservoir water was utilised as Eddystone Lighthouse ride – note the boat slide. The recent picture shows the now covered reservoir and base of the BBC tower, which reaches over 1,000 feet above sea level.

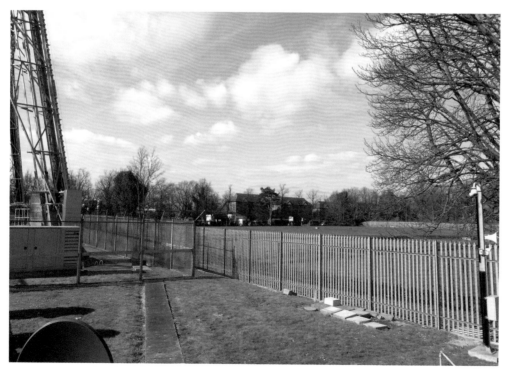

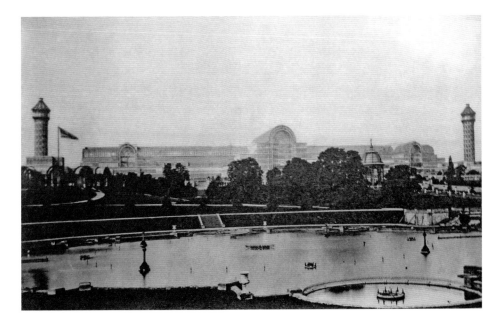

Crystal Palace, c. 1860

The rebuilt Crystal Palace on Penge Hill was opened on 10 June 1854 by Queen Victoria. A large part of the grounds were in Beckenham, which also benefitted from the prestige and economic benefits of having this cultural and entertainment giant in the neighbourhood. Beckenham station was opened in 1857, via Crystal Palace, the provision of rail transport encouraged house-building nearby. The north part of the Crystal Palace was destroyed by fire in 1866. Aquaria were built near the North Tower, and the ruins can be seen in the lower picture. The archaeologists have revealed some of the tanks adjacent to the base of the former North Tower, which is to the right.

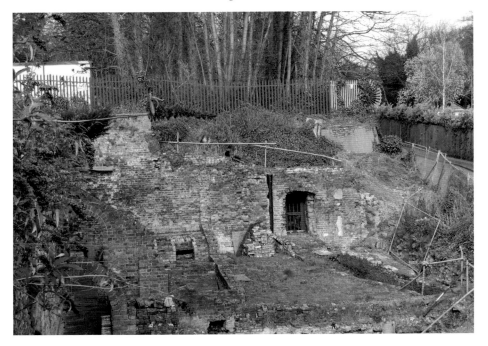

Cromwell Road, 2014

Julie Andrews lived at No. 15 Cromwell Road from 1943 until 1948. It was in those years that her musical talents and her voice were developed. From her ninth birthday, in October 1944 until September 1945, she had to commute to London for her education. Her mother decided this was too much and moved her to Woodbrook School for Girls, No. 2 Hayne Road. Here she really blossomed into a singer worthy of performing at a London event for the then Queen and Princess Margaret. Afterwards, she was introduced to the Queen. In Beckenham she lived like her friends, cycling to school and attending children's Saturday morning cinema at the Regal (now Odeon). At the height of the V1 raids, she would stand look-out on top of the Anderson shelter in the family garden. Her voice was strong enough to warn the neighbours of an approaching doodlebug. Julie Andrews was happy in Beckenham as she showed in *Home, A Memoir of My Early Years*.

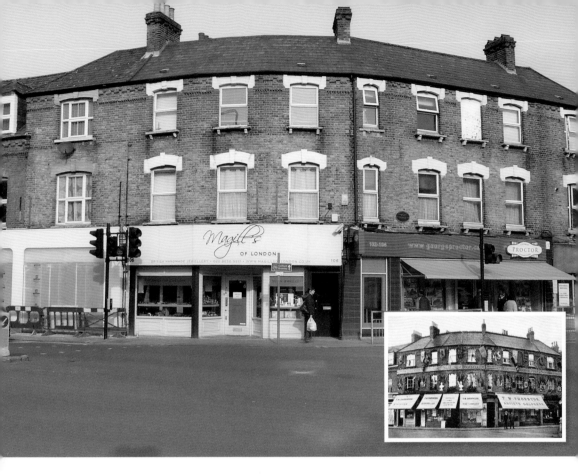

Thornton's Corner

The Coronation of George V in 1911 is probably being celebrated with the decorations over Tom Thornton's premises, where the High Street bends round to Church Hill. The business sold stationery, ran a library and published newspapers. One of his publications was the *Beckenham Journal*. This was started in 1876 by William Malyon of Victor Road, Alexandra Estate, who was a director of a London printing firm. Tom Thornton purchased this paper from W. Malyon ,converting it from a monthly issue to a weekly publication from Saturday 20 January 1883 onward. At this date, it contained eight pages measuring 17 inches by 22 inches. The early editions contain national news, as well as local poultry thefts and other minutiae, such as 130 names attending a fancy dress party and their outfits. The printing of the paper in Beckenham ended in 1955, when it was sold to *The Kentish Times*. In 2014, a variety of businesses are shown, and there is a plaque celebrating the long-serving Thornton enterprise.

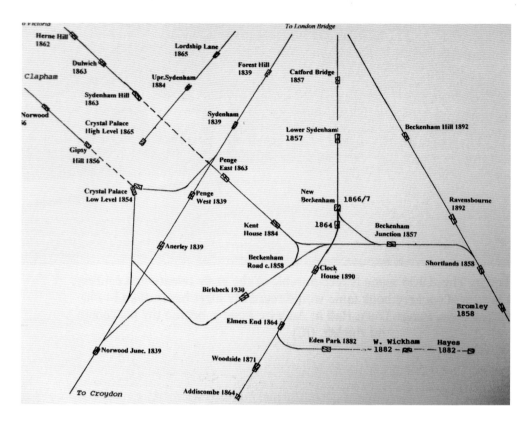

Maps of Beckenham

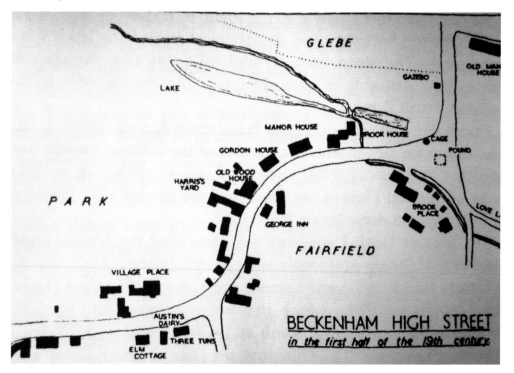